Design it Yourself
Web Sites

ROCKPORT

Design it Yourself
Web Sites

A Step-by-Step Guide
AVI ITZKOVITCH and ADAM TILL

GLOUCESTER MASSACHUSETTS

ROCKPORT PUBLISHERS

First published in the United States of America by
Rockport Publishers, Inc.
33 Commercial Street
Gloucester, Massachusetts 01930-5089
Telephone: (978) 282-9590
Fax: (978) 283-2742
www.rockpub.com

ISBN 1-56496-760-3

10 9 8 7 6 5 4 3 2 1

Cover Design: Vernacular Design
Layout: Leslie Haimes

Printed in China

Acknowledgments

I would like to thank many people for their contributions to this project: Kristin Ellison and everyone at Rockport Publishers, for allowing us the opportunity and creative freedom to write this book. Sefi Freiman (zeroHosting.com), for Web sites I designed while under the umbrella of your company—Frontier Adventure Racing, Inc., Vivienne Williams Enterprises, and InterviewPros—and for your advice and encouragement. Guy Dagan (coolinnovations.com) and Avi Reem (Web-X-Press.net), for your continued support and help throughout. Noa Weinstein (noa1.com), for providing many of the illustrations in this book, and for all your support and encouragement. And of course, Adam Till, for taking my ideas, helping me organize them, and writing the text of this book in a clear, compelling manner. Your word skills gave this work a wonderful feel, for which I am indebted to you.

—Avi

I would like to thank the following: Kristin Ellison and Rockport Publishers, for providing a friendly, supportive environment within which to work. Guy Dagan, for your help in coordinating this effort and for your ever-present understanding and support. Michael Levine, for your advice and guidance at the outset of this project. All my family and friends, for your support and encouragement. And, most of all, Avi Itzkovitch, for creating all the wonderful images in this book and for allowing me the opportunity to take your thoughts and express them in my own way. You've taught me a great deal, and I am forever appreciative.

—Adam

"Creativity is allowing yourself to make mistakes. Art is knowing which ones to keep."
—Scott Adams, *The Dilbert Principle*

Contents

PART 1

Learn the steps necessary to research, design, and produce a Web site that meets your needs as well as the needs of the user. Part 1 includes everything from defining your goals to testing the site.

PART 2

Create a design using any one of twenty-five design recipes. Each recipe includes detailed information about designing a Web site using different grids, typefaces, and color palettes.

INTRODUCTION
A Design Idea Book

Designing a Web site is a twofold process that requires technical knowledge to physically implement the site as well as design knowledge to build an effective and usable product. Quite often, books on Web design focus on the technical side— how to write HTML, how to use Flash, and so on. Though such know-how is essential to producing a site, these technical books often ignore the creative and strategic aspects of Web design, which is why this book is different. *Design-It-Yourself: Web Sites* assumes technical knowledge and, unlike others, focuses on the design aspects of building a Web site.

The first half of the book will take you through the process of building a site step by step. Again, the focus is on design, not implementation. These nine chapters help with the subtle, artistic elements of site building, including writing a mission statement, planning a site's structure, and choosing a design style. Though these aspects of creating a Web site are not as tangible as the technical aspects, they are equally if not more important.

The second half of the book features twenty-five design templates meant to give you ideas and inspiration when designing your own site. Each template deals with a different aspect of Web design. Examples include Creative Marketing, Using Angles, and Color Harmony. Images of the home page, subpages, and other key elements are provided for each, along with design specifications that allow for duplication of the various components of the site.

The best way to use this book is to follow the steps, then use the templates for inspiration, perhaps employing portions of a number of them as you create your own design. A Web site should be a personal expression of the soul and spirit of the person or company it represents. As you read this book, look for aspects of each site that resonate with you on a visceral level. Try to build the site that works best for you and that reaches your audience in the most effective and interesting way possible.

We urge you to read this book in its entirety rather than to focus on certain chapters or templates. Building a comfort level with design theory is vital to the development of an effective, aesthetically pleasing site whose coloring, layout, and other design elements combine for a professional presentation. Read this book not only for its content but also as an example of good design. See how the chapters apply to one another. For example, look at the Online Branding chapter and see how the chapter on Creative Marketing applies in that template. Understanding design theory is difficult because it is intangible, but mastering it will greatly assist you in your site-building efforts.

To the same end, we urge you to examine as many Web sites as possible and to observe the design aspects of books on other subjects. The more you are immersed in the design world, the more you will understand and appreciate the many relevant design considerations. This book deliberately returns to certain key design concepts again and again, with the intent of familiarizing readers with important design notions; the goal is for you to internalize them and later apply them on a subconscious level.

We, the authors, have been working in Web design for a number of years and have amassed a good deal of knowledge and experience. Our intention here is to convey as much of that information as possible, to give you the benefits of the significant time we have spent pursuing this art form. Feel free to visit our site—www.multimediaSpatula.com —to see our latest work and current projects. This site also contains links to a number of the sites used as templates in this book, allowing you to see these in full, online form.

Good Web design, like other types of design, comprises elements that are often difficult to articulate, but one can master certain basic rules and paths in order to design effectively. This book does as much as possible to familiarize readers with Web design theory and to lead them in the direction of finding their personal design style. Yet it is ultimately up to each designer to do the necessary research and make the effort to gain an understanding of what is required to produce an attractive, usable Web site. We hope you achieve your goals in building the site that is right for you; we think this book will help you to do so.

PART 1
Step-by-Step Design

STEP 1

Defining Your Goals

Setting a Strong Foundation for Building a Web Site

The temptation, when creating a Web site, is to immediately choose a design style. This approach ignores at the outset a crucial factor: the goals of your site. It follows that such an approach may result in an inappropriate design. If you begin, instead, by focusing on what your site is about and on its objectives, the appropriate design style should follow naturally.

Different Web sites have different purposes and, therefore, require different design approaches. You may be trying to tell a story, sell a product, demonstrate a process, or present information about a company.

The design of your site will depend on what you want to achieve. Your goals in creating a Web site will affect its content as well as its presentation.

Considering the unique qualities of the Internet is important in defining the goals of your site. A Web site can reach people in ways that printed media and other forms of promotion cannot.

One consideration is that Web sites can be viewed by anyone in the world—a fact that is relevant now more than ever, with more and more people having Internet access. As you define your online goals, be sure to consider how to present to such a large and diverse audience.

In today's business climate, companies often will not be taken seriously unless they have an online presence. When you hand people a business card, they expect to see a Web address they can use learn more about your company. This is another consideration to be taken into account in defining your objectives. How you want to present your company online is all important in designing its Web site.

Reproducing and reprinting a pamphlet can be expensive and time consuming. Web sites, however, can be changed relatively easily and without incurring printing costs. In defining your Web goals, you should consider when and how you intend to update your site, and what techniques you can employ to keep users abreast of new information.

The interactive nature of a Web site is another consideration to be examined. Unlike printed media, Web sites can be designed to allow users to interact with a representative from your company, ask follow-up questions, or buy products online. You should think about how you might take advantage of Web interactivity in setting out goals for your site.

A final feature deserving consideration is the almost infinite space you have to convey information on a Web site. There is virtually no limit to the amount of material that can be displayed. If, for example, your company offers a complex process about which users want to know, you could outline it in a section of your site. Be sure, however, to organize large amounts of information effectively so as not to confuse users. Thus, considering what information to present—and how to present it—is another important factor in defining your Web objectives.

In sum, you should consider the information you want to present, how you want to present it, and how you would like users to interact with your site, given the unique medium that is the Internet. After addressing these considerations, you should be ready to define the goals of your Web site. Remember—defining your goals is a critical step in identifying the right overall design of your site.

STEP 2

The Mission Statement

Identifying What You Want to Achieve

Now that you've laid out your goals, the next step is to outline your prospective achievements in a sentence or short paragraph known as a mission statement. A *mission statement* should be concise and clearly defined and should summarize what you are trying to achieve as you build your site. Setting out a mission statement is an important part of the design process, even though it does not, in itself, relate directly to the construction of the site.

Creating a mission statement is an effective way to focus your ideas and to think in as much detail as possible about what you can achieve via your site. Referring to this statement during the design process should help you maintain your direction and prevent your going off on unintended tangents.

A mission statement is different from a statement of goals in that it addresses not what you want to achieve ultimately but what is achievable in the near term as part of the current project. Look through your goals and assess what you can achieve in the available time frame with the available resources. A good mission statement is a realistic assessment of what you can do right now. One of your stated goals may be to have a complete e-business sales structure on your site, but if you do not have the resources to deal with online sales right now, this goal should not be part of your mission statement. Instead, include only those aspects of the goal that can be achieved immediately—for example, a setup where clients can indicate their interest in purchasing online from you so a company representative can contact them when the system is in place.

Mission statements that are vague and general are not useful. For example, the statement "In building a Web site, I would like to publicize my product online" is applicable to just about every Web site and does not provide any insight into the specific site being created. Consider the following statement:

"In building a Web site, I would like to create an online identity that portrays my company as stable and dependable and that shows users new product innovations as they come out. I would also like to create user interactivity in the form of a chat room where users can communicate directly with representatives from my company, to ask questions and generally comment on our business and products."

This is a concise, specific account of what the developer is trying to achieve. It outlines particular goals and, where possible, notes how these will be reached.

To achieve a final mission statement, the following steps are recommended:

1. Review the goals you set out in step 1. Note general patterns or categories that appear.

2. To the extent possible at this point in the process, write down how you intend to achieve your goals with specific features on your site. Include even obvious points. This will help you think about how you want to market yourself and create interactivity with users.

3. Write down any limitations you may have. These could include time, money, and technical know-how. Be realistic; creating your Web site can be a long process.

4. Attempt to set out a schedule for when (and if) each of your goals can be achieved. Again, err on the conservative side. Your mission statement should be an accurate assessment of what you can do with current resources.

5. With the preceeding points in mind, write out your mission statement. Ensure that it is realistic, concise, focused, and specific enough to be of value in guiding you through the design process.

STEP 3

Doing Research

Understanding Your Audience

Now that you have ascertained your goals and set out a mission statement, it is time to start thinking about your audience and how to best present to them. Information-gathering is always an essential step in determining who should, and will, be using your site. Formal market research, informal surveys of friends, or discussions with business associates can all be effective ways of finding out who your users will be.

The key to knowing your audience is understanding your industry. Who are your customers now, and who will they be in the future? How do these customers break down demographically? What types of computer systems do they have? Good comprehension of the nature of your industry is a key component of the research process.

The appropriate design of a Web site depends on who will use it. The education, Web experience, age, gender, location, and technological know-how of your audience are all relevant factors. For example, if you are designing a site where target users are aged sixty to seventy-five, you should take into account that they may not be as technologically savvy or have the high-tech equipment of a younger audience. Thus, you might want to avoid elaborate animation that requires a state-of-the-art machine to run

Depending on who your audience is and what you want to tell them, the content and writing style on your site will also differ. For example, if designing for people with a specific lifestyle, you might use language appropriate to that group. Designing for a corporate audience, you might want to use straightforward language, with an emphasis on clarity and brevity. Similarly, if a site is likely to be frequented by users for whom English is a second language, it might be advisable to minimize the complexity of the language used.

In thinking about how to present to a specific audience, try putting yourself in the shoes of a member of that group. If you were one of these users, what would you want to know? Where would you look to find it? What type of site would be easiest to navigate? Understanding your audience will help you understand how you should present your site—

how you can provide the user with the best tool possible for disseminating the desired information.

Once you have decided what type of content you want to include in your site, you must then begin collecting the specific text and images. Refer to existing printed materials, if necessary. If these are not inclusive enough, think, as before, about what your users will want to know when visiting your site. This should help facilitate the content-creation process.

Research is crucial in that it affects the overall direction your site will take. Look at competing sites, and assess how they cater to whom. Competing companies have likely performed their own research, and you may be inspired by aspects of their sites you like or feel work well. It is also important to investigate your competition so you can differentiate your site, if that is important to you. The key is to get it right, so that the design of your site is appropriate to your future audience.

Target Audience

STEP 4
Planning the Site

The Site Map:
Defining Interactivity with Users

At this stage, you're ready to start thinking about how you would like to structure your Web site. The users themselves will ultimately decide how to navigate your site, but the structure you choose will lead them in certain directions. Be sure to take your time and really contemplate this vital part of the design process. Good early structural planning will undoubtedly help later.

Structure implies priority. The most prominently displayed pages of your site are the ones users will assume are the most important. Keeping this in mind, make sure the best features of your business or portfolio are front and center and easy to access from anywhere in your site. Effective product placement in a Web site can make a product or service seem especially attractive or important.

For example, a site promoting a number of products might feature one of them several times within the site. The picture of the featured product could appear higher on the page than the other products' images so it will be the first one seen. Such placement implies importance and priority.

A site offering a service should make the most prominently displayed link on the home page the link to the page that outlines the service itself as opposed to a secondary page of supporting content. This link would likely be placed farthest to the left on the page so it's seen first (assuming left-to-right reading). Such placement indicates that this is the location of the core content.

It is important to keep subject areas, and thus the pages of your site, distinct and well defined. In some cases, an About Us page and a Company History page will contain largely identical information. If this is the case, it's wise to combine these pages into one or ensure that different information is presented on each page. It is both unprofessional and off-putting to users to find the same information displayed throughout your site.

Depending on the information you wish to present, various site structures may be appropriate. If you're presenting a step-by-step process, your site may be best served by a linear structure, as illustrated by the site map at the top of the opposite page. In this case, perhaps only Next and Back buttons are necessary to

Linear Structure

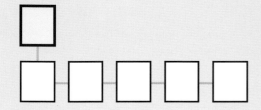

Hierarchial Structure

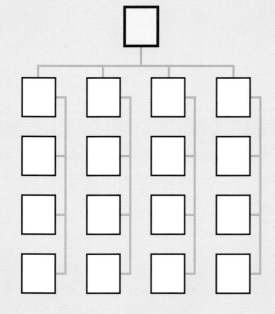

Grid Structure

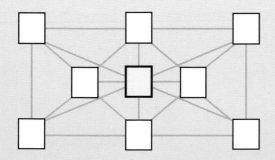

help users navigate the site. More commonly, sites take on a hierarchical structure similar to the site map in the middle. In this case, main subject areas are accessible from the home page, and detailed pages are accessible from these subpages. Depending on the quantity of information and number of topics being presented, the site can have any number of sublevels.

Less common navigation structures can also be used, depending on what's appropriate for your situation. Navigation designs such as grid structures and web structures can be used in certain situations, most commonly in sites with reference materials where pages are linked free-form to one another. These structures, such as the one shown at the bottom of this page, should be used carefully and only where the content requires it. They may prove confusing to users because no point of reference forms a base for navigation.

It is important to think logically about which pages will be accessible from each page of your site. Accessible pages should relate to the subject of the page being viewed to avoid confusing the user. In most sites, the home page can be reached from every page. Though a link from the home page is often sufficient, in some cases you may wish to have numerous links to a page. For example, if your company has a brand-new product you'd like to give special exposure to, you may choose to make that page accessible from both the products page and the home page.

A good site map is essential to an effective Web site. It helps the designer focus on clarity and priority in the organization of the site as well as expose potential structural problems early in the process. Your site map will not only make the design process smoother but also result in a site with better usability.

STEP 4: SITE MAP PLANNING CHECKLIST

1. List all the key points you would like to address on your site.

2. Group these points into topic areas or categories.

3. From this list, create individual pages you would like to have on your site.

4. Ensure content does not overlap from page to page; make certain each page covers a distinct subject area.

5. You may find it useful to divide subjects into subcategories if a topic area is large or to organize content more effectively. From these, create subpages. Again, ensure a distinct subject area is covered on each page.

6. Select a navigation structure that, based on the importance of the information within the site and what you want users to see first, best suits your content.

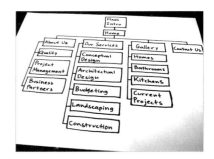

TIP: TWO-CLICK RULE

Every page on a site should be accessible from every other page within two clicks. This ensures easy navigation through the site and a forthright presentation of all information.

STEP 5

Choosing a Design Style

Projecting an Image

Based on the previous steps, you should now be able to establish a design style. Having considered the goals you've set out, the mission statement you've written, and the research you've done, the style that is right for you should be apparent. Your site's design style should unite all the factors you have identified into one cohesive effect.

The style of your site can be described as the feel it ends up having through your use of color, imagery, and typeface. These, together, create a specific atmosphere. The style you choose can be unique to the industry you are in or reminiscent of a specific genre you wish to represent. Examples of types of design styles include professional, elegant, fresh, artistic, cutting edge, and nostalgic.

To an extent, the industry you are in will dictate the style you choose. Certain industries call for certain types of styles; in many cases, you may feel forced to design within certain constraints. But to the extent you are able to do so without disassociating yourself from your industry, it is generally beneficial to be creative and, perhaps, just a little bit different. Consider the industry you are in but also how you want to present your own company. A distinctive design style can make an impression on users and help them remember your company and your site.

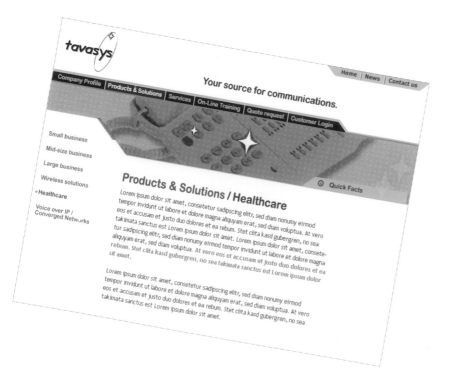

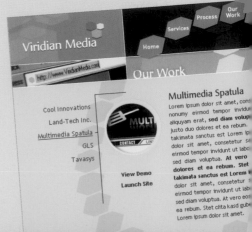

The templates in the second half of this book are excellent resources that can be utilized in choosing a design style. Whether you're inspired by one of the templates or choose to draw on aspects of several of them, they provide a variety of possibilities applicable to a wide range of industries. Always think about your target audience when considering a design style. Be sure the style you choose will be familiar to them, which will make the site easy for them to work with.

If your company already has a corporate identity, make sure your Web site is consistent with it with respect to colors, typeface, and so on. Your visual image is key to your company's success. People identify companies with their branding, so if the design style on your Web site differs from your other visuals, users could be confused, which would be costly to your business.

Through your site's design, you should make your purpose clear. A site focused on sales should have an aggressive style that clearly focuses on getting users to buy the product. A site providing instructions on carrying out a process should have an altogether different style—a more conservative feel that stresses order and clarity.

Make sure the style you choose matches the content you are trying to present and the goals you are trying to reach. The right style will help users understand your site's content. Also, be sure to balance content and style with respect to volume. It is never beneficial to present large amounts of dense text with no interesting stylistic elements. Conversely, it is of no benefit to display elaborate graphics and images with no information. Presenting a moderate amount of content with the right amount of stylistic effect will make your text look interesting and informative and make users apt to read it.

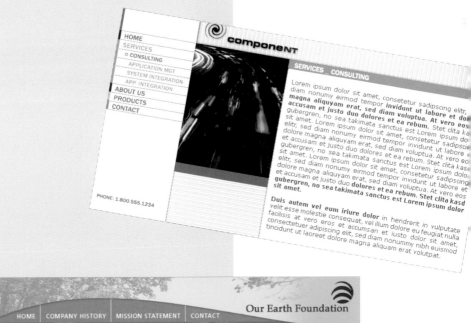

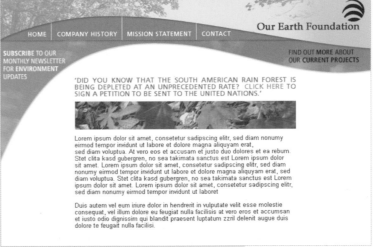

STEP 6

Choosing Your Design Tools

Understanding the Options

What you will be able to design depends, to a large extent, on the tools you use during the process. Your design tools are your medium of delivery, allowing you to bring your vision to your audience. Lots of software is available for designers of all levels—but it is important not to let this abundance of tools intimidate you. You needn't learn the ins and outs of each and every program. As long as you can use the tools necessary for your particular project, you will be able to achieve what you set out to do.

Keep in mind that design tools are just that—tools. Knowing how to use them is advantageous, but a good understanding of design is the crucial factor in creating a Web site. Use this book and other sources as a means of attaining a comfort level with design and design theory. No matter how many programs you are able to use, you will not be produce an attractive, effective Web site without a solid grounding in design principles.

Graphic Authoring Software

You will encounter three main categories of Web design programs as you seek tools for your site. The first is *graphic authoring software*. These programs, which can be either vector or bitmap based, enable you to visually display a design or design concept for a Web site. Examples of graphic authoring software are Adobe Photoshop, JASC Software Paint Shop Pro, Macromedia Fireworks, Corel DRAW, Adobe Illustrator, and Macromedia Freehand.

Interactivity/Animation Software

The second category of design program is *interactivity/animation software*. These programs allow you to create interactive or animated elements in the manner you want them to appear on your site. Examples of interactivity/animation programs are Macromedia Flash, Macromedia Director Shockwave Studio, and Adobe Live-Motion.

HTML Authoring Software

The third category of design program is *HTML authoring software*. HTML authoring programs enable you to transfer your design into HTML code. These programs bring together everything you've built with graphic authoring software and interactivity/animation programs, creating HTML pages that can be published to the Web. Examples of HTML authoring software are Macromedia Dreamweaver, Adobe Go Live, and Macromedia Home Site. Experts who know how to write HTML code can simply use a text editor.

Design programs available vary in cost and complexity. Some are meant for professionals, while others target home users. You needn't buy the most complex, expensive software in order to implement your design. Research the different programs, examining what they do and the level of expertise they require. Select the ones that best suit the type of Web site you intend to produce.

This book focuses on design considerations with respect to creating a Web site—the most important part of the Web design process. Though technological know-how is assumed, the design teachings are sufficiently general to apply to almost any software. The programs noted above are just a few of the more popular ones—many other good programs are available, any of which can be used to create your desired Web site. The key to choosing the right tools is to consider all factors and to make logical choices given your design needs, technological capabilities, and budget.

STEP 7
The Design Process

Executing Your Plan

By now, you should have all the elements needed to design a Web site. All your content, images, and so on should be planned; your site map should be prepared; and you should have a good knowledge of your industry and customers and a marketing strategy based on this research. If you do not have branding already in place, you should have developed an image for your company based on the preceeding. With all this in order, you are ready to prepare a rough sketch.

A rough sketch is a preliminary version of what each page on your site will eventually look like. In creating this, consider the elements you have decided on and the tools you are able to or have elected to use. These will guide you as you prepare your sketch. Also, think about the types of interactivity you have chosen or would like to incorporate into your site. Considering the functionality of your design is an important aspect of preparing an effective plan.

A rough sketch can be simply done on a sheet of paper. Executing the sketch is a brainstorming exercise in which you attempt different layouts in order to find one you like and one that fits the elements you want to use. Draw what you want where you want it. If the result doesn't work, try again. Try all sorts of possibilities, using different elements or placing elements in different positions on

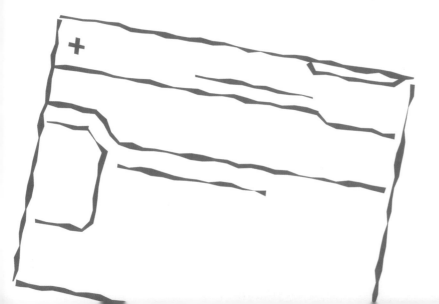

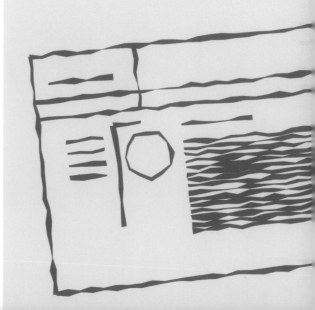

the page. Keep in mind all the considerations noted previously. And remember, a rough sketch should be just that—rough. You needn't be an artist to effectively execute this stage of the design process. This exercise is simply a way to see what your pages will eventually look like from a layout perspective—so the aesthetic qualities are irrelevant.

As you produce your sketch, ensure your pages will be easy to use. Remember—layout for a Web site is different from layout for a book or magazine. Users will interact with the design you create, unlike in printed media. Take inspiration from the templates in this book if you see something you like or are having trouble coming up with ideas. Producing an aesthetically pleasing page layout that is easy for users to interact with is often tricky, but it is essential to an effective Web design.

Once you have tried several possibilities, decide on a final rough sketch. Be sure it meshes with the work you did in prior steps. Attempt to look beyond the sketch and envision how your design will actually appear on the computer screen. Your ability to visualize the end product from a sketch will help ensure a layout you are happy with.

Your rough sketch completed, you are ready to build your site. Using a graphic authoring program, begin to bring together all the desired elements in accordance with the layout conceived in your sketch. When this is done, be sure

that the planned layout actually works when executed on screen. Usability problems often are not clear until the site is actually tested. Make changes and adjustments until you feel the design is ready, and remember—your Web site reflects you and your company. It is of the utmost importance that it look good, that it is intuitive to use, and that you are happy with it.

As you design, ask friends and business associates to test the site; keep track of their responses and reactions. To help determine whether or not you are achieving your goals for the site, ask them to explain your design to you. Make changes until you are completely satisfied. Finally, always consider whether what you are doing will be implementable, given your resources and the limitations of the Web.

CHECKLIST

We suggest following these steps as you go through the design process:

1. Consider all the work you did in previous chapters.

2. Put all the desired elements into a rough sketch; try a number of layouts.

3. In creating a rough sketch, consider the effects of interactive elements and the overall usability of the site.

4. Visualize what each sketch will actually look like on screen. Choose the one you like best based on the goals you wish to achieve.

5. Build the site using a graphic authoring program.

6. Ensure the design works; get outside opinions.

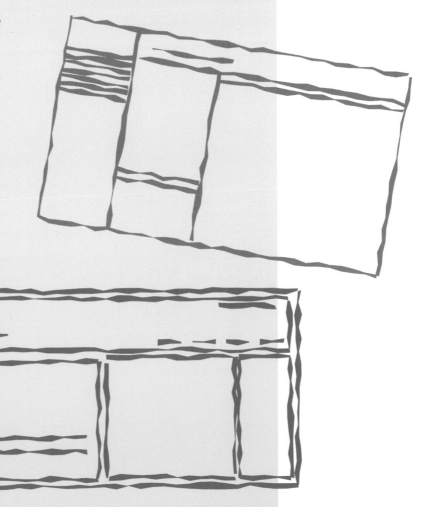

Step 8

Technical Considerations

Thinking beyond Design

Though the focus of this book is design considerations with respect to creating a Web site, a few technological matters nonetheless merit discussion. While this section is not intended to examine all possible issues, it does review the more important technical notions.

Monitor Sizes

A vital consideration when creating a Web site is designing your site for the appropriate size monitor. At the time this book is being written, 15-inch monitors with 800 × 600 (pixels) resolution are most common. After accommodating the Internet browser's navigation bars, address box, borders, scroll bar, and so on, the remaining space is approximately 760 × 480 (this is currently the standard size used by designers when designing a site). If your design is smaller than these dimensions, the pages of your site will not take up the full computer screen for most users; if your pages are larger than these dimensions, users will have to scroll to see your design in its entirety.

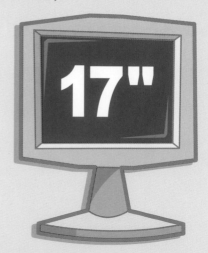

It is safest to keep the page width at the standard 760 pixels. While scrolling up and down to see a page is relatively common, scrolling side to side can be awkward and irritating. Also, keep an eye on recent trends with respect to monitor sizes. Just a few years ago, 13-inch monitors, at a resolution of 640 × 480, were standard; soon, 17-inch monitors, at a resolution of 1024 × 768 (resulting in a 960 × 550 standard Web design size), could become the norm. As you begin to create your site, look at current monitor size standards and design yours accordingly.

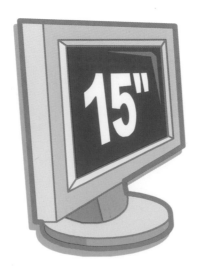

26

Flash and HTML

Another important consideration is the Flash-HTML debate. A site can be designed entirely in HTML, entirely in Flash, or using HTML with Flash elements. HTML is a solid resource for displaying text and images on the Web. Flash, on the other hand, can present animation and sound in addition to text and images. Each option has advantages and disadvantages.

HTML loads step by step; first text shows, and then images appear as they download to the computer. Flash, on the other hand, needs to finish loading entirely before users see content, so many designers incorporate a loader movie for people to watch while they wait. Additionally, HTML is relatively easy to implement, while Flash is more time consuming and requires an understanding of action scripts. But though HTML shows visuals more quickly and is easier to execute, it cannot produce animation or sound and limits text presentation to the basic system fonts. Flash, on the other hand, can use any font in its display of content. These are just a few of the many differences between HTML and Flash. Consider these factors in the context of your specific site as you asses which technology will best suit your needs and your situation.

GIF and JPEG

Saving images to the Web is another issue meriting discussion. The two main formats for saving Web images are GIF (Graphics Interchange Format) and JPEG (Joint Photographic Experts Group). Both of these compress data to limit the amount of memory used for each file. Each does so in a different way, and each has a different method of displaying visuals.

GIF uses a color palette of 256 colors to compress memory. JPEG, on the other hand, compresses information using algorithms and can display an unlimited number of colors. Because of its limited color palette, GIF tends to be better for displaying titles, navigation bars, illustrations, and animations. JPEG, which is not restricted by a palette, is excellent for displaying photographic images with many subtle tones and hues. Regardless of which format you use, adjust the level of compression to achieve your optimal result. Consider the need for detail in the image as well as the benefits of reducing file size for a faster load time.

The aforementioned are just some of the many technical issues you will encounter in designing a Web site. Like it or not, technical matters will take up a good deal of your time as you move toward your goal. It is important to deal with these matters at the beginning so you can make the right decisions. Doing so will free up your time, allowing you the opportunity to design a site that is right for your needs.

GIF. IMAGE

JPEG. IMAGE

TIP: GAMMA CORRECTION

In general, Mac monitors tend to be brighter (1.8 gamma) and PC monitors darker (2.5 gamma)—with the result that your site will never look the same on both. As you design your site, think about gamma correction and which system your target users are most likely to have. Adjusting to a gamma of 2.2 will, on average, provide the best results on all platforms.

STEP 9
Testing the Site
The Final Hurdle

After a lot of hard work, you have reached the end of the journey. Your site has been designed, constructed, and implemented in HTML. All that remains is to upload your site to the Web. Before you take this final step, however, you must test the site. Though all of your pages have been carefully considered and designed with precision, it is crucial to make sure, one last time, that your site functions in the manner intended.

A central reason to test your Web site is to ensure there are no broken links—that is, links that don't lead anywhere. It is also important to confirm that all functional links actually lead to where they are supposed to. Be sure to test all internal and external links, including e-mail links, and verify that all e-mail addresses listed are correct. Additionally, check to make sure all links are up to date. Broken, incorrect, and dated links are unprofessional and will irritate people, causing you to make a bad impression on users and perhaps lose their business. If possible, get an outside party to check your Web site for you; you may be too immersed in your site to be able to detect errors.

Another goal of testing your site is ensuring the alignment of elements from page to page. Verify that your titles, content, and so on sit in the same place on each page of your site. Though some sites intentionally have misaligned pages, generally, it is aesthetically pleasing and professional for each page to have its elements laid out in the same way. Also, it is generally best to have a small amount of space between where your content ends and the bottom border of each page. This space should be identical from page to page, or the effect will be unsettling to users.

Browser Considerations

It is vital to test your site on several browsers. The three main browsers are Internet Explorer, Netscape Navigator, and Opera. Each of these operates differently. Though they all understand HTML, they interpret it in different ways. As a result, elements may shift, fonts may get bigger or smaller, and other changes may appear depending on the browser used. Do your best to make your site work on all browsers. Though you probably won't be able to achieve your ideal result on each, attempt what is best for all three. Give greatest attention to the browser your target market is most likely to use.

Keep in mind that browsers have different versions, some more recent than others. Try to keep old versions around for testing purposes and test your site on all major versions to the extent possible. Avoid including features your target users' systems won't be able to run. It is, however, possible to have different versions of your site, with users choosing which they want to view (for example, you can offer both a Flash and a non-Flash site). This will show your commitment to accommodating a varied audience.

Platform Considerations

Also remember to test your site on the three main operating platforms accessible to users: Windows, Mac, and Linux. If you don't have these available, try to use friends' or colleagues' systems. Viewing your site on different platforms is a crucial part of the testing process. Each of these platforms operates differently, and they do not all possess the same fonts or display information in the same way. Again, do what you can to make your site work on each of the platforms, with emphasis on the platform your target audience is most likely to use.

Though perhaps not as creative as the rest of the design process, site testing is crucial to usability and functionality. Be diligent in ensuring that your site operates in the intended manner and that users will experience your design in the optimal fashion.

Design it Yourself

PART 2
Design Templates

PART 2

How to Use the Templates

The remainder of this book contains templates for twenty-five types of Web sites. We recommend you take inspiration from the templates, perhaps incorporating aspects of a number of them to create your own unique design. A Web site should be personal and customized to the particular individual or company as well as the audience. Using these templates as background, you should be able to acquire an overall design sensibility, allowing you to build your ideal site.

HOME PAGE: Each template starts off by displaying the site's home page. This page begins the site's navigation and introduces its overall design style.

SUBPAGE: Following the home page, subpages are displayed. These pages, which present subsidiary information, have a design that is similar to, but slightly different than, the home page.

POP-UP PAGE: Pop-up pages display small pieces of information—for example, a privacy policy—that do not require an entire page. They are often simply scaled-down versions of the home page.

SUPPORTING IMAGE: These images exhibit and explain certain design elements on the site. They are meant to show the thinking of the designer in the creation of the various site components.

COLOR PALETTE: The palette shows the colors, including their hex values, used on the site. See page 156.

SITE MAP: The site map is the flowchart of the site's navigation. It outlines the structure of the template site.

CSS (CASCADING STYLE SHEET): This is code that helps with the implementation of a number of the elements found in the site's design. For more information on CSS, see page 34.

HOME PAGE

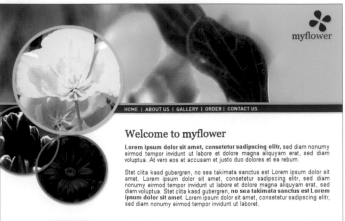

COLOR PALETTE

#FCEEE2

#DB751C

#B44611

#BF3F00

SUBPAGE

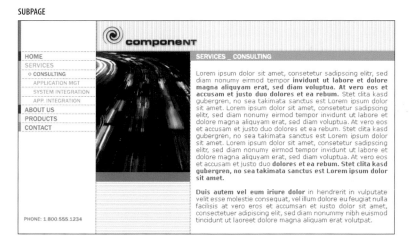

MAP

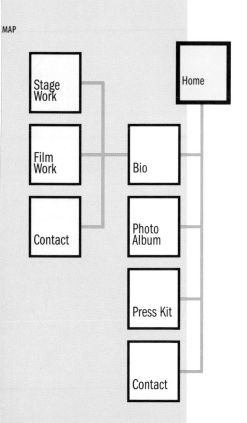

SUPPORTING IMAGE

THINKING BEYOND THE WEB

POP-UP PAGE

CLOSE WINDOW

PRIVACY POLICIES

Lorem ipsum dolor sit amet, consetetur sadipscing elitr, sed diam nonumy eirmod tempor invidunt ut labore et dolore magna aliquyam erat, sed diam voluptua. At vero eos et accusam et justo duo dolores et ea rebum. Stet clita kasd gubergren, no sea takimata sanctus est Lorem ipsum dolor sit Lorem ipsum dolor sit amet, consetetur sadipscing elitr, sed diam nonumy eirmod tempor invidunt ut labore et dolore magna aliquyam erat, sed diam voluptua. At vero eos et accusam et justo duo dolores et ea rebum. Stet clita kasd gubergren, no sea takimata sanctus est Lorem ipsum dolor sit amet. Lorem ipsum dolor sit amet, consetetur sadipscing elitr, sed diam nonumy eirmod tempor invidunt ut labore et dolore magna aliquyam erat, sed diam voluptua. At vero eos et accusam et justo duo dolores et ea rebum. Stet clita kasd gubergren, no sea takimata sanctus est Lorem ipsum dolor sit amet.

Cascading Style Sheets

The CSS (Cascading Style Sheet) is a standard layout language for the Web that controls typography, colors, and the size and placement of images and elements. A CSS is usually created in a separate file and called from within the HTML on page load. CSS conveys many benefits, including a reduction in development, updating, and maintenance time as well as the need for less bandwidth. CSS is a complex topic; here, we briefly discuss how to incorporate CSS with the designs featured in this book.

Each template in this book has a CSS associated with it. If copied into a text editor and named *style.css*, the CSS file can be used to duplicate the relevant features of the particular Web site. In order to access the CSS for a given site, use the following HTML tag `<link type="text/css"rel="stylesheet" href="style.css">`. Placing this tag within the HTML document HEAD tag activates the CSS for the site.

The CSS for each template is set out at the end of the chapter and can be utilized in the manner outlined. These particular examples work with the exact sites shown and can also be changed as necessary. All aspects of each CSS should be fully functional wherever the site is viewed, except the scroll bar specifications, which may not be supported on all versions of all browsers. Use these CSSs as you please as you create your own Web site.

The CSSs in this book control the following:

SCROLL BAR COLORING: This can be set to match a site's design. Shown here is a figure outlining which scroll bar features can be specified.

```
BODY {
scrollbar-face-color: #0662BC;
scrollbar-highlight-color: #2A84DD;
scrollbar-3dlight-color: #2883DC;
scrollbar-darkshadow-color: #023668;
scrollbar-shadow-color: #075097;
scrollbar-arrow-color: #E6F1FD;
scrollbar-track-color: #E6F1FD;}
```

TEXT SIZE, COLOR, AND FONT: These features are set out in the CSS, then applied throughout the site.

TD {font-family: Verdana, Arial, Helvetica, sans-serif; font-size: 11px; color: #117EEB;}

P {font-family: Verdana, Arial, Helvetica, sans-serif; font-size: 11px; color: #117EEB;}

HYPERLINKS: The CSS specifies the change in appearance on rollover (for example, underline, bold).

```
A:link {color: #117EEB; }
A:visited {color: #117EEB; }
A:hover {color: #117EEB; text-decoration: none; }
A:active {color: #117EEB; }
```

CUSTOM STYLES (CLASSES): Areas of text can be specifically defined by the designer (for example, titles, subtitles, footers) to have particular qualities; anything else normally controlled from within a CSS can be specified in the class (for example, typeface, size, color). Classes are common when using CSS, as generally designers want different features for the different areas on each page.

```
.Title {font-size: 14px; font-weight: bold; }
.SubTitle {font-size: 11px; font-weight: bold; }
.Footer {font-size: 10px; }
```

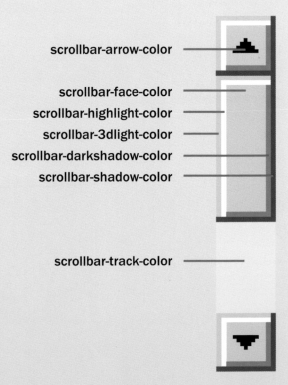

scrollbar-arrow-color

scrollbar-face-color
scrollbar-highlight-color
scrollbar-3dlight-color
scrollbar-darkshadow-color
scrollbar-shadow-color

scrollbar-track-color

The various aspects of your scroll bar, including its color, size, and shape, can be specified from within the CSS.

STYLE 1

The Splash Page

A Gateway to Your Web Site

A *splash page* is an opportunity for you to showcase your company image and possibly dazzle users with a bit of pizzazz. Though not every site has or needs a splash page, if one is used, it is the first page displayed when users access your site. Once a splash page has been viewed, users cannot return to it within the site's navigation structure. Like a book cover, a splash page should be designed to attract users and make them interested in your Web site.

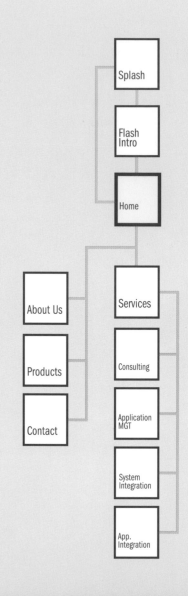

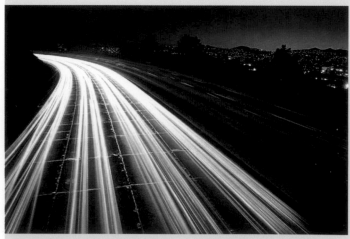

Two relatively large images have been cropped to fit particular spaces—a common design technique. This site uses images of traffic and motion to represent the fast-paced information superhighway. It is a good idea to choose a theme and use it throughout your site.

#DBDBDB

#D07F20

#104F6F

#90AF2F

#A03F20

#F1C37B

#7FA0BF

Though the design of a splash page should be consistent with the design of the rest of your site, its structure need not be identical. It is generally most effective if, as with a teaser meant to generate interest, it is a little bit different from the other pages on your site. That said, your splash page should echo your site's design and color scheme so it is an identifiable part of the whole.

Your splash page can contain a small amount of text, though its purpose is not to present information. It is a good idea for it to contain your company's tag line or a catchphrase explaining what your company is about. If users cannot immediately ascertain who you are and what you do, they may be tempted to leave your site and search elsewhere.

A splash page can also give users options regarding the viewing of the site. Users might be allowed to choose the language in which they would like to see the site, and the site could have a function whereby it remembers the appropriate language for each user. Another option on a splash page is to provide a Skip Intro button so users may elect to skip the introduction if they do not have the time or if they viewed it during a previous visit.

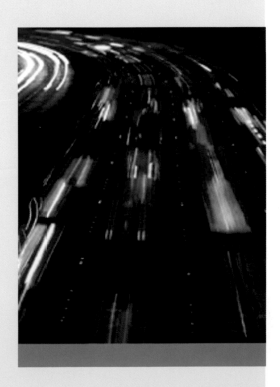

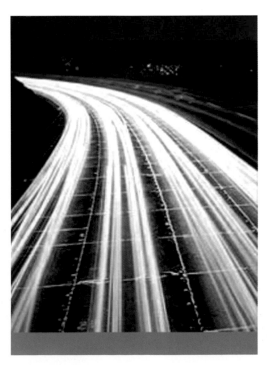

SPLASH PAGE

COMPLETE NETWORK SOLUTIONS

PHONE: 1.800.555.1234

WLECOME TO COMPONENT - HTML

WLECOME TO COMPONENT - FLASH INTRO (150KB)

Copyright 2003 componeNT
Lorem ipsum dolor sit amet, consetetur sadipscing elitr, sed diam nonumy eirmod tempor invidunt ut labore et dolore magna aliquyam erat, sed diam voluptua.

HOME PAGE

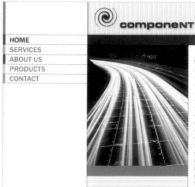

HOME
SERVICES
ABOUT US
PRODUCTS
CONTACT

HOME

COMPUSHIRE - COMPLETE NETWORK SOLUTIONS

Lorem ipsum dolor sit amet, consetetur sadipscing elitr, sed diam nonumy eirmod tempor invidunt ut labore et dolore magna aliquyam erat, **sed diam voluptua.** At vero eos et accusam et justo duo dolores et ea rebum. Stet clita kasd gubergren, no sea takimata sanctus est Lorem ipsum dolor sit amet. **Lorem ipsum dolor sit amet, consetetur sadipscing elitr, sed diam nonumy eirmod tempor invidunt ut labore et dolore magna aliquyam erat,** sed diam voluptua. At vero eos et accusam et justo duo dolores et ea rebum. Stet clita kasd gubergren, no sea takimata sanctus est Lorem ipsum dolor sit amet. Lorem ipsum dolor sit amet, consetetur sadipscing elitr, sed diam nonumy eirmod tempor invidunt ut labore et dolore magna aliquyam erat, sed diam voluptua. At vero eos et accusam et justo duo dolores et ea rebum. Stet clita kasd gubergren, **no sea takimata sanctus est Lorem ipsum dolor sit amet.**

PHONE: 1.800.555.1234

SUBPAGE

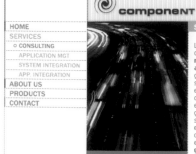

HOME
SERVICES
 ○ CONSULTING
 APPLICATION MGT
 SYSTEM INTEGRATION
 APP INTEGRATION
ABOUT US
PRODUCTS
CONTACT

SERVICES _ CONSULTING

Lorem ipsum dolor sit amet, consetetur sadipscing elitr, sed diam nonumy eirmod tempor **invidunt ut labore et dolore magna aliquyam erat, sed diam voluptua. At vero eos et accusam et justo duo dolores et ea rebum.** Stet clita kasd gubergren, no sea takimata sanctus est Lorem ipsum dolor sit amet. Lorem ipsum dolor sit amet, consetetur sadipscing elitr, sed diam nonumy eirmod tempor invidunt ut labore et dolore magna aliquyam erat, sed diam voluptua. At vero eos et accusam et justo duo dolores et ea rebum. Stet clita kasd gubergren, no sea takimata sanctus est Lorem ipsum dolor sit amet. Lorem ipsum dolor sit amet, consetetur sadipscing elitr, sed diam nonumy eirmod tempor invidunt ut labore et dolore magna aliquyam erat, At vero eos et accusam et justo duo **dolores et ea rebum. Stet clita kasd gubergren, no sea takimata sanctus est Lorem ipsum dolor sit amet.**

Duis autem vel eum iriure dolor in hendrerit in vulputate velit esse molestie consequat, vel illum dolore eu feugiat nulla facilisis at vero eros et accumsan et justo odio dignissim qui blandit praesent luptatum zzril delenit augue duis dolore te feugait nulla facilisi.

PHONE: 1.800.555.1234

POP-UP PAGE

PRIVACY POLICIES | CLOSE WINDOW

Lorem ipsum dolor sit amet, consetetur sadipscing elitr, sed diam nonumy eirmod tempor invidunt ut labore et dolore magna aliquyam erat, sed diam voluptua. At vero eos et accusam et justo duo dolores et ea rebum. Stet clita kasd gubergren, no sea takimata sanctus est Lorem ipsum dolor sit Lorem ipsum dolor sit amet, consetetur sadipscing elitr, sed diam nonumy eirmod tempor invidunt ut labore et dolore magna aliquyam erat, sed diam voluptua. At vero eos et accusam et justo duo dolores et ea rebum. Stet clita kasd gubergren, no sea takimata sanctus est Lorem ipsum dolor sit amet. Lorem ipsum dolor sit amet, consetetur sadipscing elitr, sed diam nonumy eirmod tempor invidunt ut labore et dolore magna aliquyam erat, sed diam voluptua. At vero eos et accusam et justo duo dolores et ea rebum. Stet clita kasd gubergren, no sea takimata sanctus est Lorem ipsum dolor sit amet.

HOME
SERVICES
ABOUT US
PRODUCTS
CONTACT

HOME
SERVICES
ABOUT US
PRODUCTS
CONTACT

Each of the home page options is associated with its own color; the color appears both on the navigation bar and as an edge color for the relevant subpage. This method helps users determine their location within the site.

Adding lines to the gray area enriches the image by giving it texture. Subtle patterns such as this one can contribute greatly to the overall look of your site.

Cascading Style Sheet (CSS)

```
BODY {
scrollbar-face-color: #DFA969;
scrollbar-highlight-color: #F4E0C8;
scrollbar-3dlight-color: #E5CBAC;
scrollbar-darkshadow-color: #76562F;
scrollbar-shadow-color: #9F7E5A;
scrollbar-arrow-color: #F4E0C8;
scrollbar-track-color: #F6E5D2;
}

TD {font-family: Verdana, Arial, Helvetica,
sans-serif; font-size: 12px; color: #666666; }

P {font-family: Verdana, Arial, Helvetica,
sans-serif; font-size: 12px; color: #666666; }

A:link {color: #D07F20; }
A:visited {color: #D07F20; }
A:hover {color: #666666; text-decoration: none; }
A:active {color: #666666; }

.TitleHome {font-size: 15px; color: #104F6F; font-weight: bold; }
.TitleServices {font-size: 15px; color: #90AF2F; font-weight: bold; }
.TitleAbout {font-size: 15px; color: #A03F20; font-weight: bold; }
.TitleProducts {font-size: 15px; color: #F1C37B; font-weight: bold; }
.TitleContact {font-size: 15px; color: #7FA0BF; font-weight: bold; }
.SubTitle {font-size: 14px; }
.Footer {font-size: 9px; }
```

TIP: JUSTIFICATION

When presenting text, it is possible to right align, left align, or justify so both sides are aligned with their respective edges of the HTML TABLE. The latter technique can be effective, making your content look neat and easy to read. To justify text within the width of a TABLE, use the following DIV tag: <DIV align="justify"> text here </DIV>

STYLE 2

The Home Page

Navigation and Presentation Are Critical—Right From the Start

Your *home page* is crucial in that it is the point from which users begin to navigate your site. It is also a first opportunity to display your company image. Although this is a cliché, it's true: You never get a second chance to make a first impression. Your home page should contain your logo, a tag line, and/or a short paragraph about your site/company—namely, who you are and what you do.

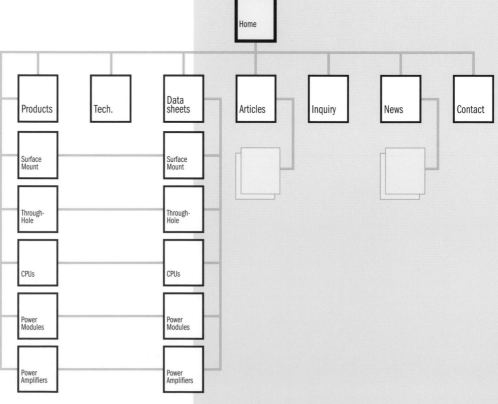

#ECF2FF

#CCDCFF

#679AFF

#CC3300

Pictures on your home page will be thought to represent the spirit of your company, so choose them carefully. Possibilities for home page images include a product line, a picture of a service being performed, or anything else that identifies what your business is about.

Clarity is of the utmost importance on a home page with respect to both text and navigation. If the text on your home page is difficult to understand and the purpose of your company unclear, people will likely lose interest and leave your site. Similarly, if navigation options are unclear or illogical, users may well choose not to navigate any further.

A clear navigation system is a vital part of every home page, and users should be able to find the subpages of your site easily. Subpages should be scaled-down versions of the home page—clearly related to the home page design, yet distinguishable from it. It is important for the navigation on all subpages to contain a return link to the home page, as users might arrive on a subpage from an external link or a search engine. For the same reason, each subpage should contain your logo and tag line so as to identify your company/site to users who arrive there without first seeing your home page. Navigation bars should always appear in the same place and present options in the same order on each page of your site, whether home page or subpage. This consistency will give your site a sense of continuity and avoid confusing and losing users.

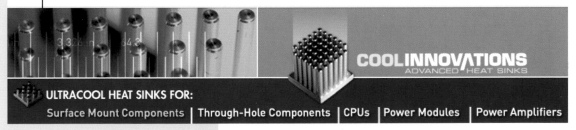

This site uses multiple navigation bars, which allow users to easily locate any product at any point in the site.

Equally important is easy access to your contact information, which is essential and a key to good business. In this site, the phone number and e-mail address of the company are located at the bottom of each page.

The tiny, red-and-blue diamond heat sinks are a special feature. Clicking the blue brings the text you are reading to the top of the page; clicking the red brings you back to the actual top of the page.

41

HOME PAGE

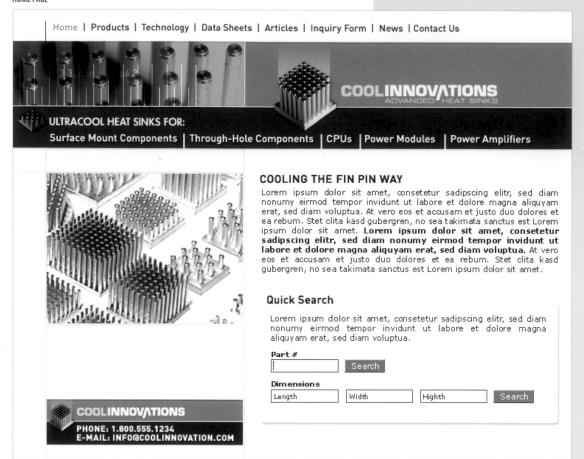

POP-UP PAGE

SUBPAGE

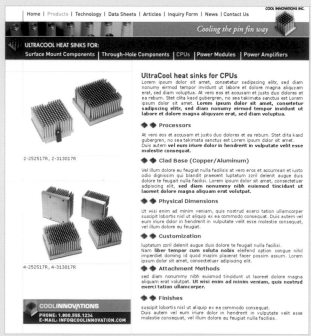

Each page of the site contains several crisp images that showcase the product. Displaying your product so that it is attractive and, thus, appealing to users is an important aspect of any Web site.

Cascading Style Sheet (CSS)

```
BODY {
scrollbar-face-color: #B7C8EE;
scrollbar-arrow-color: #ECF2FF;
scrollbar-track-color: #ECF2FF;
}

TD {font-family: Verdana, Arial, Helvetica,
sans-serif; font-size: 11px; color: #000066; }

P {font-family: Verdana, Arial, Helvetica,
sans-serif; font-size: 11px; color: #000066; }

A:link {color: #CC3300; }
A:visited {color: #CC5C37; }
A:hover {color: #CC3300; text-decoration: none; }
A:active {color: #CC3300; }

.Title {font-size: 15px; color: #000066; font-weight: bold; }
.SubTitle {font-size: 14px; color: #3366CC; }
.Footer {font-size: 9px; }
```

TIP: WINDOW TITLES

The window title at the top of each page, which is related to your HTML TITLE tag, should contain the name of your company and a brief explanation of what you are about. Choose keywords that express the most information in the least amount of space; this will increase the chances of your site coming up on search engines. The following is an example of an effective window title:

```
<TITLE> Cool Innovations, Inc.—leading
manufacturer of Heat Sinks for surface-mount
components and CPUs </TITLE>
```

Web site designed for:

Cool Innovations, Inc.

www.coolinnovations.com

STYLE 3
The Design Grid
Your Key to a Professional-Looking Site

The design grid gives physical reference to what is otherwise uncharted space. If used properly, grid alignment can give your site a professional look with a minimum of effort. Something as simple as aligning your logo with the text below it can make your page both more attractive and easier to read.

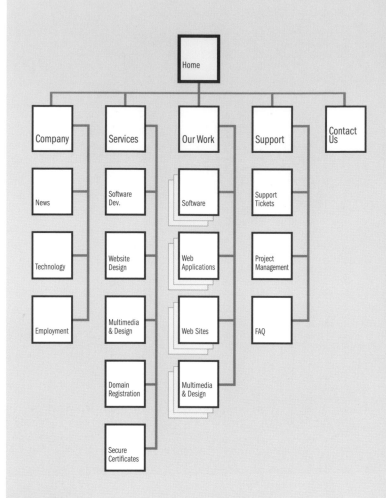

HOME PAGE

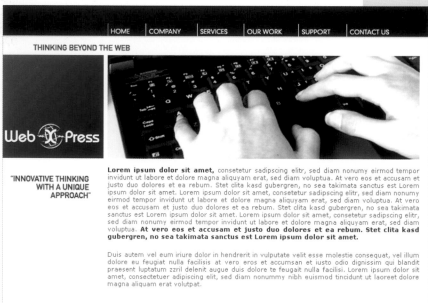

Note that the company's slogan, "Thinking beyond the Web," is outside the grid, not aligned with the other elements. This technique is meant to emphasize the slogan. As you can see, your attention is drawn to it because of its contrast to the aligned elements of the page.

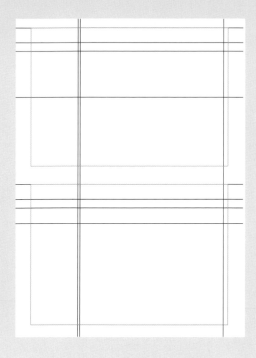

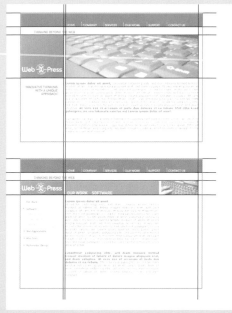

A grid is a two-dimensional guide to the space on your screen. It is important to align key elements both vertically and horizontally to give your page a pleasing feel. A grid also ensures identical alignment on *different* pages of your site, even where dissimilar elements are used. Consistent alignment from page to page is undetectable if done well but obvious and unsettling if done poorly.

Even where a page appears to be a mess of images and text, an underlying grid often aligns the elements, giving a page a professional look. Though in rare instances it can be ignored for artistic reasons, in most cases the grid is essential.

SUPPORTING IMAGE

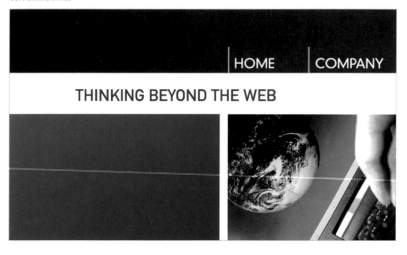

#E7EBEF
#EFF3FF
#9CB2F7
#21519C
#00307B

Vertical and horizontal alignment orders the contents of each page. We also see that the alignment from page to page is consistent. This gives the site an aesthetically pleasing, professional, cohesive look.

SUBPAGE

SUBPAGE

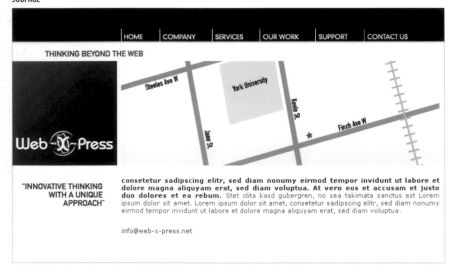

Consistency within and between the pages of a site is critical; it lends credibility both to the site and to the person or company behind it. Solid alignment within the grid is aesthetically pleasing at an unconscious level and shows the competence and professionalism of the site's designer.

POP-UP PAGE

PRIVACY POLICIES

Lorem ipsum dolor sit amet, consetetur sadipscing elitr, sed diam nonumy eirmod tempor invidunt ut labore et dolore magna aliquyam erat, sed diam voluptua. At vero eos et accusam et justo duo dolores et ea rebum. Stet clita kasd gubergren, no sea takimata sanctus est Lorem ipsum dolor sit Lorem ipsum dolor sit amet, consetetur sadipscing elitr, sed diam nonumy eirmod tempor invidunt ut labore et dolore magna aliquyam erat, sed diam voluptua. At vero eos et accusam et justo duo dolores et ea rebum. Stet dita kasd gubergren, no sea takimata sanctus est Lorem ipsum dolor sit amet. Lorem ipsum dolor sit amet, consetetur sadipscing elitr, sed diam nonumy eirmod tempor invidunt ut labore et dolore magna aliquyam erat, sed diam voluptua. At vero eos et accusam et justo duo dolores et ea rebum. Stet dita kasd gubergren, no sea takimata sanctus est Lorem ipsum dolor sit amet.

CLOSE WINDOW

Our Work

▸ Software

▸ Web Applications

▸ Web Sites

▸ Multimedia Design

Our Work

▾ Software

 WebX Pro 2.0

 WebX Soft 1.2

 WebX LT 1.0

▸ Web Applications

▸ Web Sites

▸ Multimedia Design

This site uses Flash-based navigation with menus collapsing along the left side of the page. Notice how even the collapsing menus maintain their alignment within the grid.

Cascading Style Sheet (CSS)

```
BODY {
scrollbar-face-color: #1861A9;
scrollbar-highlight-color: #1B6DBD;
scrollbar-3dlight-color: #1966B2;
scrollbar-darkshadow-color: #10406F;
scrollbar-shadow-color: #134B82;
scrollbar-arrow-color: #EFF0FF;
scrollbar-track-color: #EFF0FF;
}

TD {font-family: Verdana, Arial, Helvetica,
sans-serif; font-size: 11px; color: #666666; }

P {font-family: Verdana, Arial, Helvetica,
sans-serif; font-size: 11px; color: #666666; }

B {color: #003078; }

A:link {color: #003078; }
A:visited {color #003078; }
A:hover {color: #336699; text-decoration: none; }
A:active {color: #003078; }

.Title {font-size: 15px; color #003366: font-weight: bold; }
.SubTitle {font-size: 14px; color: #336699; }
.Footer {font-size: 9px; }
```

STYLE 4

Grid Design

Effective Use of Space

An effective method for maintaining clarity is to place different types of information in distinct sections on each page. A page can be divided into boxes and rectangles, each covering a different topic area or displaying a different type of content. Such a format is easy for users to understand and straightforward for them to use.

A visually well-structured site can contain any number of sections accommodating images and text, all of which appear in harmony. As each of the components of your site will have its own space, users will always be able to find what they are looking for and will thus be more comfortable as they approach your layout and navigate through the content.

Using a grid design to create clearly ordered pages ensures a professional and focused look. Good organization and a solid site structure also help avoid confusion. Placing all elements in a clear, well-structured format puts users at ease and is the key to repeat hits and continued business.

HOME PAGE

CALL 1.800.555.1234

WORLD VACATIONS

August 20 — 12:45 am

Taking You Anywhere

The Great Outdoors
Europe Vacations
Go Down Under
Asia
South America

Home | About Us | Destinations | Hot Deals | Before You Go | Contact Us

Hot Deals

September 8
Lorem ipsum dolor sit amet, consetetur sadipscing elitr, sed diam nonumy.

September 20
Eirmod tempor invidunt ut labore et dolore magna aliquyam erat, sed diam voluptua.

Book A Trip Now!

From:

To:

Lorem ipsum dolor sit amet, consetetur sadipscing elitr, sed diam nonumy eirmod tempor invidunt ut labore et diam Vero eos et accusam et justo duo dolores et ea rebum.

Departing
Aug | 21 | Morning

Returning
Aug | 26 | Morning

Adults **Children**
1 | 0

Search World Vacations

Welcome

Lorem ipsum dolor sit amet, consetetur sadipscing elitr, sed diam nonumy eirmod tempor invidunt ut labore et dolore magna aliquyam erat, sed diam voluptua. At vero eos et **accusam et justo duo dolores et ea rebum.** Stet clita kasd gubergren, no sea takimata sanctus est Lorem ipsum dolor sit amet. Lorem ipsum dolor sit amet, sed diam nonumy eirmod.

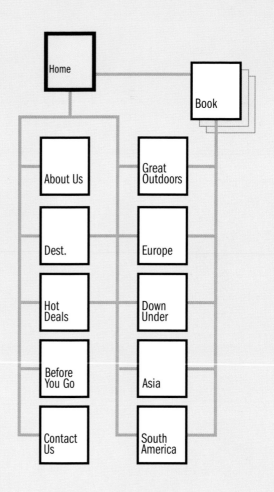

#FAE8A8

#D8CAA1

#B7A669

#8B7A3D

SUBPAGE

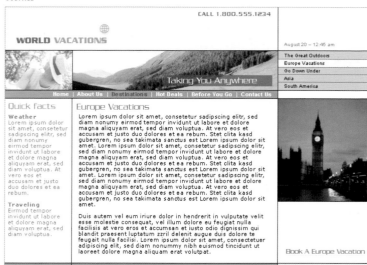

SUBPAGE

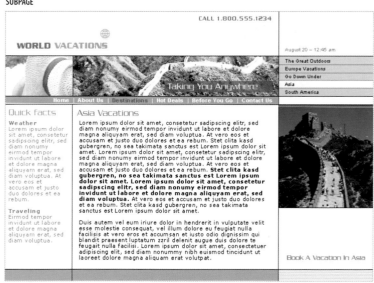

POP-UP PAGE

	Close Window

Privacy Policies

Lorem ipsum dolor sit amet, consetetur sadipscing elitr, sed diam nonumy eirmod tempor invidunt ut labore et dolore magna aliquyam erat, sed diam voluptua. At vero eos et accusam et justo duo dolores et ea rebum. Stet clita kasd gubergren, no sea takimata sanctus est Lorem ipsum dolor sit amet. Lorem ipsum dolor sit amet, consetetur sadipscing elitr, sed diam nonumy eirmod tempor invidunt ut labore et dolore magna aliquyam erat, sed diam voluptua. At vero eos et accusam et justo duo dolores et ea rebum. Stet clita kasd gubergren, no sea takimata sanctus est Lorem ipsum dolor sit amet. Lorem ipsum dolor sit amet, consetetur sadipscing elitr, sed diam nonumy eirmod tempor invidunt ut labore et dolore magna aliquyam erat, sed diam voluptua. At vero eos et accusam et justo duo dolores et ea rebum. Stet clita kasd gubergren, no sea takimata sanctus est Lorem ipsum dolor sit amet.
Duis autem vel eum iriure dolor in hendrerit in vulputate velit esse molestie consequat, vel illum dolore eu feugiat nulla facilisis at vero eros et accumsan et iusto odio dignissim qui blandit praesent luptatum zzril delenit augue duis dolore te feugait nulla facilisi.

The image in the top left corner of each page is a woman vacationer, shown in various poses and from different angles. This is an effective method of online branding, which keeps the site uniform while providing a warm, personal feel.

This image shows the bare grid for the Web site. We see how the grid aligns the elements on the site, providing structure and order and conveying a sense of organization.

August 20 – 12:45 am

The Great Outdoors

Europe Vacations

Go Down Under

When planning a vacation online, it is useful to have the date and time in front of you. This feature also gives the site a sense of being current—important, given the nature of the industry.

Cascading Style Sheet (CSS)

```
BODY {
scrollbar-face-color: #D8C794;
scrollbar-highlight-color: #EBDCB1;
scrollbar-3dlight-color: #E2D2A2;
scrollbar-darkshadow-color: #CAB576;
scrollbar-shadow-color: #D2BE84;
scrollbar-arrow-color: #EBE4D0;
scrollbar-track-color: #EBE4D0;
}

TD {font-family: Verdana, Arial, Helvetica,
sans-serif; font-size: 11px; color: #000000; }

P {font-family: Verdana, Arial, Helvetica,
sans-serif; font-size: 11px; color: #000000; }

A:link {color: #7C6B30; }
A:visited {color: #7C6B30; }
A:hover {color: #000000; text-decoration: none; }
A:active {color: #000000; }

.Title {font-size: 16px; color: #7C6C31; }
.SubTitle {font-size: 14px; color: #7C6C31; }
.Date {font-size: 10px; color: #837E6D; }
.SideText {color: #837E6D; }
.Footer {font-size: 9px; }
```

STYLE 5
Using Angles
Cutting-Edge Design

Though a grid is essential in most Web sites, you needn't feel limited to straight lines in organizing your pages. A more liberal technique involves setting out your content and formatting your navigation bars with angles. The result is a modern, New Age design style, ideal for cutting-edge companies.

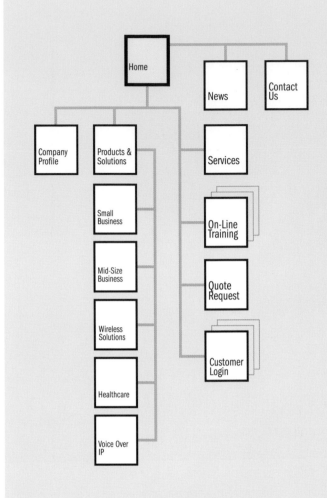

HOME PAGE

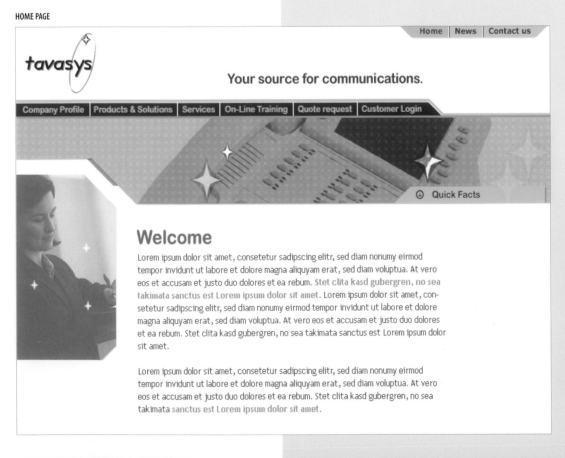

#B1BAF0

#4359AD

#384C92

#A4E745

#FF9933

#CC6600

Because the use of angles can imply a young and edgy organization, you should take into account what your company does before you decide to employ this style. A well-established bank would want to instill confidence in users with a design implying steadiness and stability, so a flashy, angular site might not be appropriate. A cutting-edge telecom company, however, might want users to see them as young and progressive. A visually appealing angular site might be more suitable to target users, increasing their interest in the company.

If you have decided to employ angles on your Web site, remember that you needn't use them throughout. Contrasting design styles—two or more on any given page—can be an effective approach. For example, you could design an entire page with straight lines but use angles to outline a specific image. This method can be visually appealing and draw attention to a particular aspect of the page.

The use of angles is an effective approach that grab users' attention and make them interested in your company. The sharp corners of an angular design might be just what you need to attract people to your Web site. As more and more companies start to think beyond the straight-line design grid, angles are becoming increasingly common in today's marketplace.

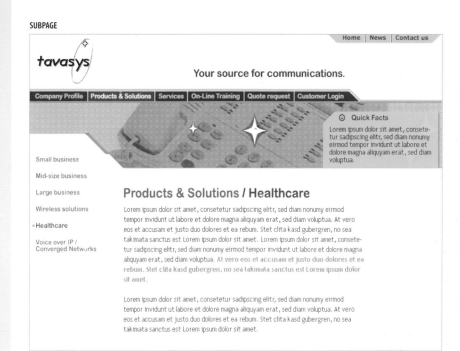

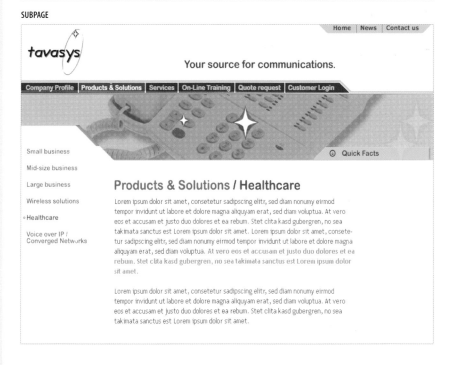

DESIGN TEMPLATES: USING ANGLES

Home | News | Contact us

This menu has been set apart from the main menu, as the types of options it presents are slightly different. Though neither menu is more important, the separation focuses each menu on its content. Both menus were designed using angles.

SUBPAGE

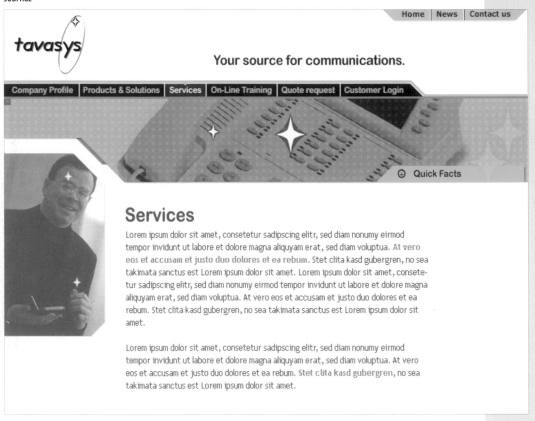

POP-UP PAGE

Lorem ipsum dolor sit amet, consetetur sadipscing elitr, sed diam nonumy eirmod tempor invidunt ut labore et dolore magna aliquyam erat, sed diam voluptua. At vero eos et accusam et justo duo dolores et ea rebum. Stet clita kasd gubergren, no sea takimata sanctus est Lorem ipsum dolor sit Lorem ipsum dolor sit amet, consetetur sadipscing elitr, sed diam nonumy eirmod tempor invidunt ut labore et dolore magna aliquyam erat, sed diam voluptua. At vero eos et accusam et justo duo dolores et ea rebum. Stet clita kasd gubergren, no sea takimata sanctus est Lorem ipsum dolor sit amet. Lorem ipsum dolor sit amet, consetetur sadipscing elitr, sed diam nonumy eirmod tempor invidunt ut labore et dolore magna aliquyam erat, sed diam voluptua. At vero eos et accusam et justo duo dolores et ea rebum. Stet clita kasd gubergren, no sea takimata sanctus est Lorem ipsum dolor sit amet.

When users roll over the company's logo, it animates and redraws itself. Simple interactivity with a logo helps people remember it—and, thus, your company.

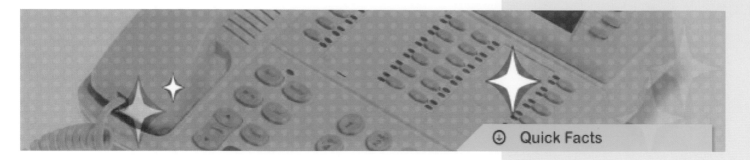

This site contains a Flash movie embedded in the HTML. Within the Flash movie is a Quick Facts button. Clicking on this button causes the tab to slide upward and reveal relevant facts about the product. Creating interactivity within a Flash component is an effective technique for keeping users' attention and interest.

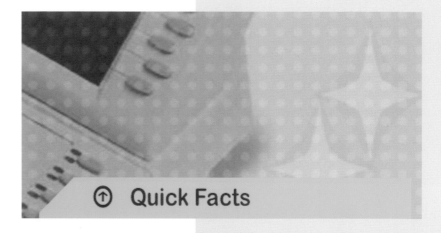

These images use stars drawn from the logo as watermarks on the images. The stars echo the logo and maintain a consistent brand feel.

Cascading Style Sheet (CSS)

```
BODY {
scrollbar-face-color: #BEC5F3;
scrollbar-highlight-color: #505B9E;
scrollbar-3dlight-color: #D0D6F9;
scrollbar-darkshadow-color: #D0D6F9;
scrollbar-shadow-color: #9EAAF2;
scrollbar-arrow-color: #3F4F90;
scrollbar-track-color: #DFE3F9;
}

TD {font-family: Trebuchet MS, Verdana, Arial,
sans-serif; font-size: 12px; color: #666666; }

P {font-family: Trebuchet MS, Verdana, Arial,
sans-serif; font-size: 12px; color: #666666; }

B {color: #FF9933; }

A:link {color: #FF6600; }
A:visited {color: #FF6600; }
A:hover {color: #CC6600; text-decoration: none; }
A:active {color: #CC6600; }

.Title {font-size: 17px; color: #CC6600; font-weight: bold; }
.SubTitle {font-size: 15px; color: #CC6600; }
.Footer {font-size: 9px; }
```

Web site designed for:

Tavasys Telecom Inc.

www.tavasys.com

STYLE 6
Using Curves

Free-Flowing Design

Though grid-aligned site designs are most common, other design styles are viable options and can make for memorable sites. While the previous template focused on angles, this template concentrates on curves and other rounded elements.

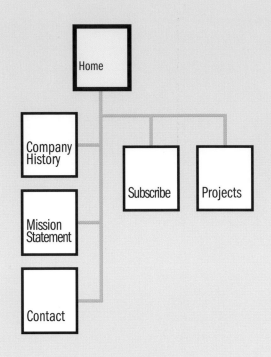

HOME PAGE

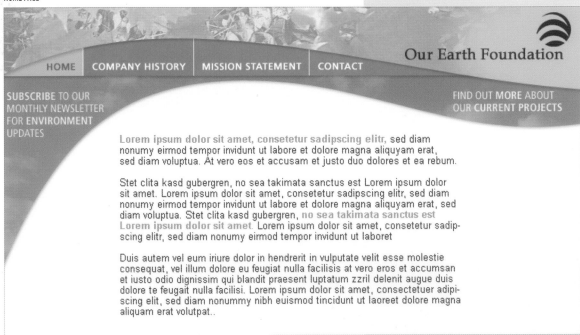

#F8F7D8

#D6D331

#C19F00

#FF9A00

#B4460A

Curves on a site imply an alternative, free-flowing person or organization. While lines are the standard and angles tend to represent the cutting edge, curves generally characterize something out of the mainstream—different from what people are used to.

Breaking out of the grid through the use of curves is an advanced technique that can be difficult to implement well. It is easiest to produce straight lines—especially verticals and horizontals—but for some people and businesses, the static feel of the grid may not be appropriate. Curves provide a sense of movement, giving the site a more organic feel.

Curves can be a refreshing change that differentiates you from the norm without implying high-tech. The softer, wavelike feel of a rounded site might prove ideal for your Web design needs. However, maintaining consistency throughout is still important, as shown here.

SUBPAGE

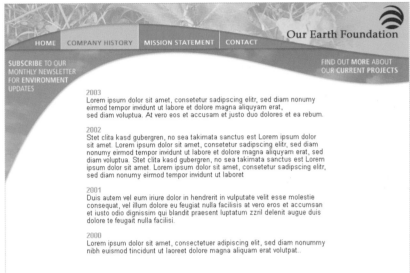

SUBPAGE

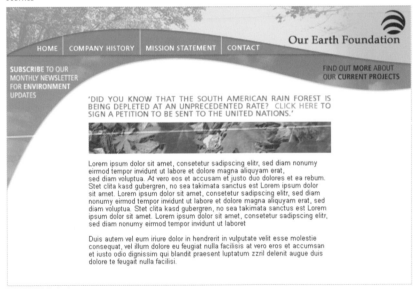

POP-UP PAGE

The background image was made larger than the page. In general, background images tile endlessly to fill the space on the monitor screen. In this instance, if a larger monitor is used, the background will not repeat itself.

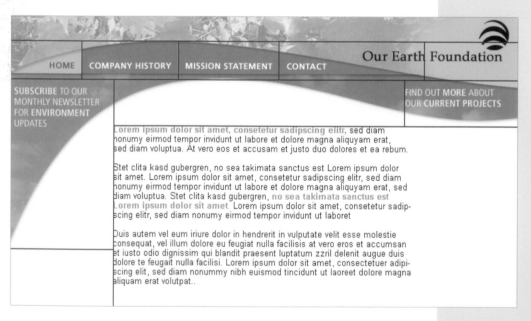

Images are always square or rectangular. When designing with curves, it is necessary to fit the rounded elements into these square frames, which sometimes makes for awkward design. Shown here is a slice map illustrating how a page using curves could be implemented in HTML.

These curved shapes were designed using a vector-based program. The curved images were then brought to a graphic authoring program to be implemented in the design. This is a good example of utilizing two programs to achieve a singular result.

Cascading Style Sheet (CSS)

```
BODY {
scrollbar-face-color: #DABC00;
scrollbar-highlight-color: #F1D420;
scrollbar-3dlight-color: #E9CB10;
scrollbar-darkshadow-color: #A28C03;
scrollbar-shadow-color: #C4AA05;
scrollbar-arrow-color: #E9E8B3;
scrollbar-track-color: #E9E8B3;
}

TD {font-family: Arial, Verdana, Helvetica,
sans-serif; font-size: 13px; color: #684004; }

P {font-family: Arial, Verdana, Helvetica,
sans-serif; font-size: 13px; color: #684004; }

B {color: #CEAA00; }

A:link {color: #AE9004; }
A:visited {color: #AE9004; }
A:hover {color: #B4460A; text-decoration: none; }
A:active {color: #B4460A; }

.Title {font-size: 15px; color: #CEAA00; font-weight: bold; }
.SubTitle {font-size: 13px; color: #CEAA00; font-weight: bold; }
.Footer {font-size: 10px; }
```

STYLE 7

Using Metaphors

Conventions in Representation

It is always a good idea to simplify your site by displaying objects that are representative of their functions. To this end, designers sometimes employ metaphors to make their designs easy to use. In the Web context, metaphors are words or images, drawn from everyday life, that represent a function on a site. For example, a picture of a telephone can serve as a metaphor representing an address book or contact list, helping simplify the design.

In recent years, the use of metaphors has become less common. Designers often try to oversimplify the elements of their design. Metaphors do not create new meanings for objects; they simply use items prominent in modern society to represent components of a site. Yet objects that exist in

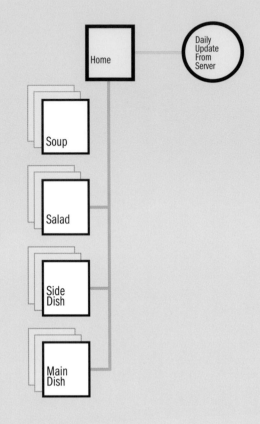

#FDDFB6

#FDB052

#1A0E82

#797676

This background image gives the page a layered look and the recipe cards a three-dimensional feel.

today's world are often insufficient to describe the complex new functions of a Web site.

Though metaphors are seen less often these days, this does not mean they cannot be used at all. If an obvious opportunity arises, a metaphor can be an effective design element. For example, a cooking site made to look like a cookbook, with recipe tabs and so on, would work because the representation is subtle and tabs are still utilized today. Similarly, a gallery section made to look like a tabbed photo album would be acceptable, as the symbolism is not flashy or overbearing, and again, the use of tabs is commonplace.

Yet one should be wary of overuse of metaphors. Displaying too many on a site can make it look dated and unprofessional. For example, the use by a sporting goods site of pictures of baseballs and basketballs as buttons to represent those topic areas would seem obvious and visually unappealing. To make your site look current, avoid excessive use of metaphors—and where you do use them, make sure they are subtle and appropriate.

When designing a site using Flash, one needn't be limited to animating images. Animation of text and titles can be an effective way of capturing users' attention and making the site feel interactive.

HOME PAGE

SUBPAGE

SUBPAGE

The displayed tabs are stacked to look like actual tabs. Each brings users to a different page on the site.

Ingredients

Lorem ipsum dolor sit amet, consetetur sadipscing elitr, sed diam.

nonumy eirmod tempor invidunt ut labore et dolore magna aliquyam erat, sed diam voluptua.

At vero eos et accusam et justo duo dolores et ea rebum.

Stet clita kasd gubergren, no sea takimata sanctus.

est Lorem ipsum dolor sit amet.

Lorem ipsum dolor sit amet.

When creating a list, separating points into colored boxes is a good way of breaking up text and making it easier to read.

Note: This is a Flash-based site. All typeface, links, titles, and so on are controlled from within the Flash movie. A CSS is not needed.

Design concept and illustrations: Noa Weinstein

STYLE 8

The Rollover

Changing Elements

The *rollover* is a common feature on Web sites today. As users roll over or run their cursor over an element, something occurs—a color changes or an animation unfolds, for example. The rollover effect can be as simple or as complex as the designer chooses.

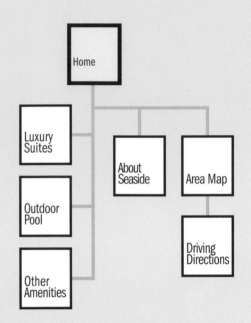

HOME PAGE

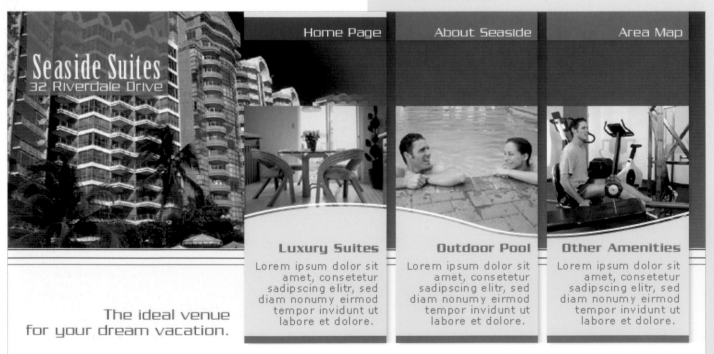

#C4E2FF

#117EEB

#0055AB

Most commonly, rollovers are seen in the context of navigation. When users roll over a menu option, it changes color or drops down to reveal a submenu. When employing rollovers that change the color of menu options, it is important to ensure that if the option is selected (that is, clicked on), its color will remain changed on the chosen page. For example, if users select the Products option from the main menu on your home page, the Products option should remain highlighted when users arrive at the Products page. This technique will greatly improve the usability of your site; users enjoy feeling they have effected a change (the option remains highlighted) and will know where they have navigated to in the site.

Highlighted selected menu options are especially important if users arrive at a page from an external link; the color-changed menu option tells them which page they are on. Even if a page has a clear title, it is still important to keep the menu option for that page highlighted because users are accustomed to this convention and may be confused if it is not followed.

But remember, a rollover needn't be just a change in color of a menu option. It can be an information bubble that appears over top of an image, a short animation that promotes a product, or anything else that suits your needs. Be creative when thinking about rollovers. Try to use them to contribute to your site's design style. Rollovers are common to today's Web sites, and if used properly, they can add greatly to your site's appearance and usability.

HOME PAGE

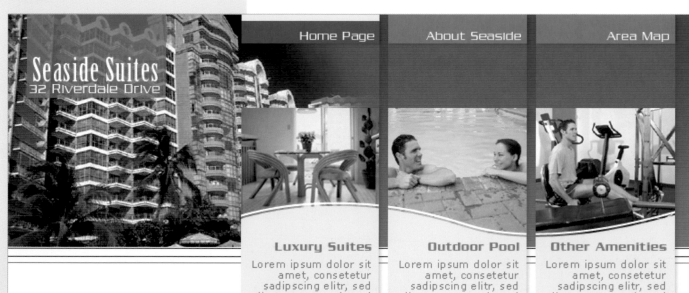

SUBPAGE

Our beautiful outdoor pool is ideal for swimmers looking for fun in the sun.

The ideal venue for your dream vacation.

Lorem ipsum dolor sit amet, consetetur sadipscing elitr, sed diam nonumy eirmod tempor invidunt ut labore et dolore magna aliquyam erat, sed diam voluptua. At vero eos et accusam et justo duo dolores et ea rebum. Stet clita kasd gubergren, no sea takimata sanctus est Lorem ipsum dolor sit amet. Lorem ipsum dolor sit amet, consetetur sadipscing elitr, sed diam nonumy eirmod tempor invidunt ut labore et dolore magna aliquyam erat, sed diam voluptua. At vero eos et accusam et justo duo dolores et ea rebum. Stet clita kasd gubergren, no sea takimata sanctus est Lorem ipsum dolor sit amet. Lorem ipsum dolor sit amet, consetetur sadipscing elitr, sed diam nonumy eirmod tempor invidunt ut labore et dolore magna aliquyam erat, sed diam voluptua. At vero eos et accusam et justo duo dolores et ea rebum. Stet clita kasd gubergren, no sea takimata sanctus est Lorem ipsum dolor sit amet.

Duis autem vel eum iriure dolor in hendrerit in vulputate velit esse molestie consequat, vel illum dolore eu feugiat nulla facilisis at vero eros et accumsan et iusto odio dignissim qui blandit praesent luptatum zzril delenit augue duis dolore te feugait nulla facilisi. Lorem ipsum dolor sit amet, consectetuer adipiscing elit, sed diam nonummy nibh euismod tincidunt ut laoreet dolore magna aliquam erat volutpat.

SUBPAGE

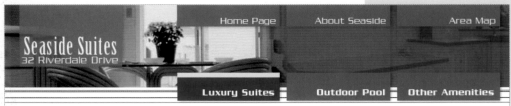

Our luxury suites range from the comfortable to the extravagant – surely there is one that is right for you.

The ideal venue for your dream vacation.

Lorem ipsum dolor sit amet, consetetur sadipscing elitr, sed diam nonumy eirmod tempor invidunt ut labore et dolore magna aliquyam erat, sed diam voluptua. At vero eos et accusam et justo duo dolores et ea rebum. Stet clita kasd gubergren, no sea takimata sanctus est Lorem ipsum dolor sit amet. Lorem ipsum dolor sit amet, consetetur sadipscing elitr, sed diam nonumy eirmod tempor invidunt ut labore et dolore magna aliquyam erat, sed diam voluptua. At vero eos et accusam et justo duo dolores et ea rebum. Stet clita kasd gubergren, no sea takimata sanctus est Lorem ipsum dolor sit amet. Lorem ipsum dolor sit amet, consetetur sadipscing elitr, sed diam nonumy eirmod tempor invidunt ut labore et dolore magna aliquyam erat, sed diam voluptua. At vero eos et accusam et justo duo dolores et ea rebum. Stet clita kasd gubergren, no sea takimata sanctus est Lorem ipsum dolor sit amet.

Duis autem vel eum iriure dolor in hendrerit in vulputate velit esse molestie consequat, vel illum dolore eu feugiat nulla facilisis at vero eros et accumsan et iusto odio **dignissim qui blandit praesent luptatum zzril** delenit augue duis dolore te feugait nulla facilisi. Lorem ipsum dolor sit amet, consectetuer adipiscing elit, sed diam nonummy nibh euismod tincidunt ut laoreet dolore magna aliquam erat volutpat.

POP-UP PAGE

Close Window

Driving Directions

From Freeway
Lorem ipsum dolor sit amet, consetetur sadipscing elitr, sed diam nonumy eirmod tempor invidunt ut labore et dolore magna aliquyam erat, sed diam voluptua. At vero eos et accusam et justo duo dolores et ea rebum. Stet clita kasd gubergren, no sea takimata sanctus est Lorem ipsum dolor sit amet. Lorem ipsum dolor sit amet, consetetur sadipscing elitr, sed diam nonumy eirmod tempor invidunt ut labore et dolore magna aliquyam erat, sed diam voluptua. At vero eos et accusam et justo duo dolores et ea rebum. Stet clita kasd gubergren, no sea takimata sanctus est Lorem ipsum dolor sit amet.

From North
Lorem ipsum dolor sit amet, consetetur sadipscing elitr, sed diam nonumy eirmod tempor invidunt ut labore et dolore magna aliquyam erat, sed diam voluptua. At vero eos et accusam et justo duo dolores et ea rebum. Stet clita kasd gubergren, no sea takimata sanctus est Lorem ipsum dolor sit amet.

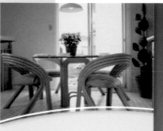
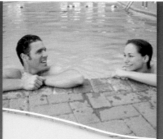

Luxury Suites

Lorem ipsum dolor sit amet, conse te tur sadipscing elitr, sed diam nonumy eirmod tempor invidunt ut labore et dolore.

Outdoor Pool

Lorem ipsum dolor sit amet, conse te tur sadipscing elitr, sed diam nonumy eirmod tempor invidunt ut labore et dolore.

Other Amenities

Lorem ipsum dolor sit amet, conse te tur sadipscing elitr, sed diam nonumy eirmod tempor invidunt ut labore et dolore.

Luxury Suites

Lorem ipsum dolor sit amet, conse te tur sadipscing elitr, sed diam nonumy eirmod tempor invidunt ut labore et dolore.

Outdoor Pool

Lorem ipsum dolor sit amet, conse te tur sadipscing elitr, sed diam nonumy eirmod tempor invidunt ut labore et dolore.

Other Amenities

Lorem ipsum dolor sit amet, conse te tur sadipscing elitr, sed diam nonumy eirmod tempor invidunt ut labore et dolore.

Luxury Suites

Lorem ipsum dolor sit amet, conse te tur sadipscing elitr, sed diam nonumy eirmod tempor invidunt ut labore et dolore.

Outdoor Pool

Lorem ipsum dolor sit amet, conse te tur sadipscing elitr, sed diam nonumy eirmod tempor invidunt ut labore et dolore.

Other Amenities

Lorem ipsum dolor sit amet, conse te tur sadipscing elitr, sed diam nonumy eirmod tempor invidunt ut labore et dolore.

As users arrive at the home page, three image options appear in duotone color. When rolled over, the images become colorized, indicating the option has been selected.

The top image for the subpage was produced in five steps. First, an appropriate base image was selected.

Next, the image was cropped to fit the desired space.

The right border was then masked to create a gradual dissolve into the blue background.

A selected section from the discarded portion of the base image was placed to the right of the first image and blended into it. This technique allowed for the display of more of the original image in the narrow rectangular space at the top of the page.

Finally, the opacity of the image to the right was reduced to 40 percent.

Cascading Style Sheet (CSS)

```
BODY {
scrollbar-face-color: #0662BC;
scrollbar-highlight-color: #2A84DD;
scrollbar-3dlight-color: #2883DC;
scrollbar-darkshadow-color: #023668;
scrollbar-shadow-color: #075097;
scrollbar-arrow-color: #E6F1FD;
scrollbar-track-color: #E6F1FD;
}

TD {font-family: Verdana, Arial, Helvetica,
sans-serif; font-size: 11px; color: #117EEB; }

P {font-family: Verdana, Arial, Helvetica,
sans-serif; font-size: 11px; color: #117EEB; }

A:link {color: #117EEB; }
A:visited {color: #117EEB; }
A:hover {color: #117EEB; text-decoration: none; }
A:active {color: #117EEB; }

.Title {font-size: 14px; font-weight: bold; }
.SubTitle {font-size: 11px; font-weight: bold; }
.Footer {font-size: 10px; }
```

STYLE 9

Creative Structuring

Utilizing Rollovers

One user-friendly way to make use of rollovers is to structure a site where navigation options leading to new pages are replaced with rollovers that trigger information displays on one central page that makes up the entire site. This one page remains consistent; however, the information block changes when menu options are rolled over. These types of sites are easy to navigate and generally appealing.

HOME PAGE

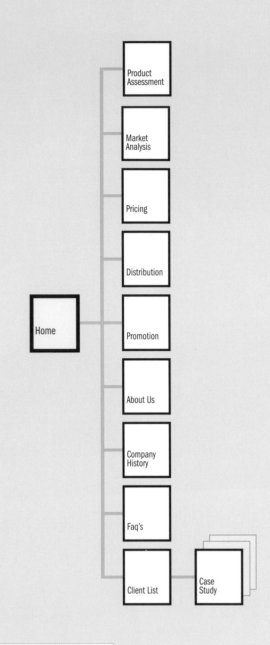

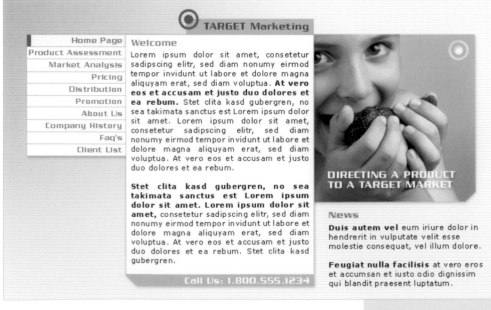

#ECF7FC

#76D6EC

#038FAF

#017691

The company's business card was used as inspiration for the site. Though not identical in design, the site maintains the basic branding originally established with the card.

Such sites appear as traditional sites with multiple pages that contain certain images, text, and a navigation bar. But when users roll over a button on the navigation bar, in addition to the option becoming highlighted, the images and text on the page change to match to the menu or option selected, so no clicking is required to see the content corresponding to each button.

If your site uses rollovers in this way, your company will appear advanced and, perhaps, out-of-the-box in its thinking. Note: Be sure to thoroughly test such a site's construction, as advanced programming is required and, as with any site, errors can occur. The design may experience variations in display, so it is especially important to test the site functions on all browsers and platforms.

Sites using rollovers as described create increased interaction with users, allowing them to see all or most of your site from one page. This is an effective method of displaying products or services, especially where users might want to compare two or more products directly. Such a Web site will differentiate you from the pack because the design is highly efficient and easy to use.

SUBPAGE

⊙ **TARGET** Marketing

Home Page
Product Assessment
Market Analysis
Pricing
Distribution
Promotion
About Us
Company History
Faq's
Client List

Market Analysis

Lorem ipsum dolor sit amet, consetetur sadipscing elitr, sed diam nonumy eirmod tempor invidunt ut labore et dolore magna aliquyam erat, sed diam voluptua. At vero eos et accusam et justo duo dolores et ea rebum. Stet clita kasd gubergren, no sea takimata sanctus est Lorem ipsum dolor sit amet. Lorem ipsum dolor sit amet, consetetur sadipscing elitr, sed diam nonumy eirmod tempor invidunt ut labore et dolore **magna aliquyam erat, sed diam voluptua. At vero eos et accusam et justo duo dolores et ea rebum.**

Stet clita kasd gubergren, no sea takimata sanctus est Lorem ipsum dolor sit amet. Lorem ipsum dolor sit amet, consetetur sadipscing elitr, sed diam nonumy eirmod tempor invidunt ut labore et dolore magna aliquyam erat, sed diam voluptua. At vero eos et accusam et justo duo dolores et ea rebum. Stet clita kasd gubergren.

DIFFERENTIATING YOURSELF AND YOUR PRODUCT

News

Duis autem vel eum iriure dolor in hendrerit in vulputate velit esse molestie consequat, vel illum dolore.

Feugiat nulla facilisis at vero eros et accumsan et iusto odio dignissim qui blandit praesent luptatum.

Call Us: 1.800.555.1234

SUBPAGE

⊙ **TARGET** Marketing

Home Page
Product Assessment
Market Analysis
Pricing
Distribution
Promotion
About Us
Company History
Faq's
Client List

About Us

Lorem ipsum dolor sit amet, consetetur sadipscing elitr, sed diam nonumy eirmod tempor invidunt ut labore et dolore magna aliquyam erat, sed diam voluptua. At vero eos et accusam et justo duo dolores et ea rebum. Stet clita kasd gubergren, no sea takimata sanctus est Lorem ipsum dolor sit amet. Lorem ipsum dolor sit amet, **consetetur sadipscing elitr, sed diam nonumy eirmod tempor invidunt ut labore et dolore magna aliquyam erat,** sed diam voluptua. At vero eos et accusam et justo duo dolores et ea rebum.

Stet clita kasd gubergren, no sea takimata sanctus est Lorem ipsum dolor sit amet. Lorem ipsum dolor sit amet, consetetur sadipscing elitr, sed diam nonumy eirmod tempor invidunt ut labore et dolore magna aliquyam erat, sed diam voluptua. At vero eos et accusam et justo duo dolores et ea rebum. Stet clita kasd gubergren.

TARGET THE WORLD

News

Duis autem vel eum iriure dolor in hendrerit in vulputate velit esse molestie consequat, vel illum dolore.

Feugiat nulla facilisis at vero eros et accumsan et iusto odio dignissim qui blandit praesent luptatum.

Call Us: 1.800.555.1234

POP-UP PAGE

Case Study ⊙ Close Window

Strawberries Kid

Lorem ipsum dolor sit amet, consetetur sadipscing elitr, sed diam nonumy eirmod tempor invidunt ut labore et dolore magna aliquyam erat, sed diam voluptua. At vero eos et accusam et justo duo dolores et ea rebum. Stet clita kasd gubergren, no sea takimata sanctus est Lorem ipsum dolor sit amet. Lorem ipsum dolor sit amet, **consetetur sadipscing elitr, sed diam nonumy eirmod tempor invidunt ut labore et dolore magna aliquyam erat,** sed diam voluptua. At vero eos et accusam et justo duo dolores et ea rebum.

Home Page
Product Assessment
Market Analysis
Pricing
Distribution
Promotion
About Us
Company History
Faq's
Client List

Home Page
Product Assessment
Market Analysis
Pricing
Distribution
Promotion
About Us
Company History
Faq's
Client List

Home Page
Product Assessment
Market Analysis
Pricing
Distribution
Promotion
About Us
Company History
Faq's
Client List

Users arrive at the home page with the Home Page menu option highlighted. As they roll over other buttons on the navigation bar, these become highlighted as well, and the text and images on the page change to correspond to the newly selected topics.

TARGET Marketing

The typeface from the logo was used for the navigation and titles throughout the site. Using a typeface from the same font family also would have been effective in achieving a similar sense of consistency.

Home Page

Product Assessment

Market Analysis

Pricing

Distribution

Promotion

About Us

Company History

Faq's

Client List

The background image is composed of thin, white-and-blue, horizontal lines. A radial gradient was added to the top left corner of the image to add body and luster to the background.

HOME PAGE

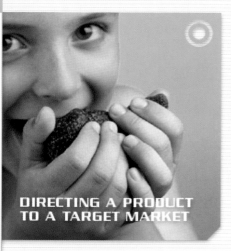

⊙ TARGET Marketing

Home Page
Product Assessment
Market Analysis
Pricing
Distribution
Promotion
About Us
Company History
Faq's
Client List

Welcome

Lorem ipsum dolor sit amet, consetetur sadipscing elitr, sed diam nonumy eirmod tempor invidunt ut labore et dolore magna aliquyam erat, sed diam voluptua. **At vero eos et accusam et justo duo dolores et ea rebum.** Stet clita kasd gubergren, no sea takimata sanctus est Lorem ipsum dolor sit amet. Lorem ipsum dolor sit amet, consetetur sadipscing elitr, sed diam nonumy eirmod tempor invidunt ut labore et dolore magna aliquyam erat, sed diam voluptua. At vero eos et accusam et justo duo dolores et ea rebum.

Stet clita kasd gubergren, no sea takimata sanctus est Lorem ipsum dolor sit amet. Lorem ipsum dolor sit amet, consetetur sadipscing elitr, sed diam nonumy eirmod tempor invidunt ut labore et dolore magna aliquyam erat, sed diam voluptua. At vero eos et accusam et justo duo dolores et ea rebum. Stet clita kasd gubergren.

DIRECTING A PRODUCT TO A TARGET MARKET

News

Duis autem vel eum iriure dolor in hendrerit in vulputate velit esse molestie consequat, vel illum dolore.

Feugiat nulla facilisis at vero eros et accumsan et iusto odio dignissim qui blandit praesent luptatum.

Call Us: 1.800.555.1234

Cascading Style Sheet (CSS)

```
BODY {
scrollbar-face-color: #F1F9FF;
scrollbar-highlight-color: #F1F9FF;
scrollbar-3dlight-color: #BAE1FC;
scrollbar-darkshadow-color: #F1F9FF;
scrollbar-shadow-color: #8EC5EB;
scrollbar-arrow-color: #BAE1FC;
scrollbar-track-color: #F1F9FF;
}

TD {font-family: Verdana, Arial, Helvetica,
sans-serif; font-size: 11px; color: #000000; }

P {font-family: Verdana, Arial, Helvetica,
sans-serif; font-size: 11px; color: #000000; }

A:link {color: #065F73; }
A:visited {color: #065F73; }
A:hover {color: #065F73; text-decoration: none; }
A:active {color: #065F73; }

.Title {font-size: 14px; font-weight: bold; color: #11ACCF; }
.Footer {font-size: 10px; }
```

STYLE 10
Color Psychology
Creating the Right Feel

The colors you use have a substantial impact on how site users feel about your company. People associate colors with certain emotions and sensations. As you present specific colors in different areas of your site, people react based on the color scheme you've chosen.

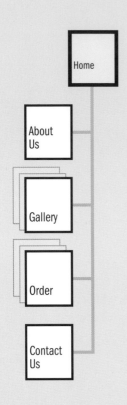

HOME PAGE

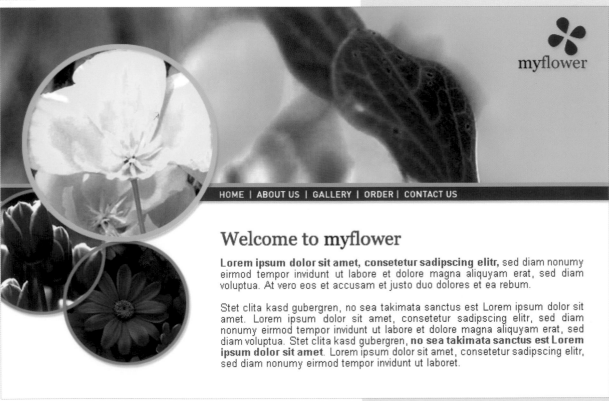

Welcome to myflower

Lorem ipsum dolor sit amet, consetetur sadipscing elitr, sed diam nonumy eirmod tempor invidunt ut labore et dolore magna aliquyam erat, sed diam voluptua. At vero eos et accusam et justo duo dolores et ea rebum.

Stet clita kasd gubergren, no sea takimata sanctus est Lorem ipsum dolor sit amet. Lorem ipsum dolor sit amet, consetetur sadipscing elitr, sed diam nonumy eirmod tempor invidunt ut labore et dolore magna aliquyam erat, sed diam voluptua. Stet clita kasd gubergren, **no sea takimata sanctus est Lorem ipsum dolor sit amet.** Lorem ipsum dolor sit amet, consetetur sadipscing elitr, sed diam nonumy eirmod tempor invidunt ut laboret.

Try to make the colors you use fit with the company or product you are presenting as well as the audience who will be using your site. For example, if you are creating a Web site for a new soft drink geared toward teenagers, you might want to litter your site with wild, vibrant colors—reds, yellows, greens. On the other hand, if you are creating a site for an office product geared toward corporate customers, you might want a more conservative color scheme, such as browns, blues, and grays.

Think about the nature of your company and the colors that suit the way you would like to present it. Certain colors tend to be associated with certain properties. Red usually represents energy, passion, power, and excitement. Blue generally signifies honesty, integrity, and trustworthiness. Neutral colors, such as grays and browns, indicate stability and balance. Consider these associations and the psychology of all the colors available to you as you design your site.

The final image for the top of each page was created in three steps. First, an image was selected that was both attractive and appropriate for the site.

Next, the image was cropped to fit the desired space, and color was added to the right side so the image would blend with a horizontal tiling background.

Finally, the company's logo was added to the top right corner.

#525963
#A5D3DE
#005573
#42F3FF

#5F6352
#DED5A5
#736900
#FFC842

#635E52
#DEB7A5
#732C00
#FF6342

SUBPAGE

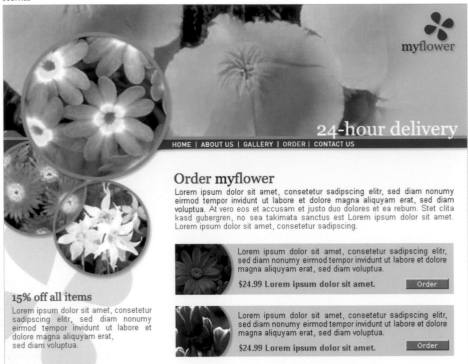

The most appealing portion of this photo was cropped into a circle. A border was then added to frame the image.

24-hour delivery

HOME | ABOUT US | GALLERY | ORDER | CONTACT US

Order myflower

Lorem ipsum dolor sit amet, consetetur sadipscing elitr, sed diam nonumy eirmod tempor invidunt ut labore et dolore magna aliquyam erat, sed diam voluptua. At vero eos et accusam et justo duo dolores et ea rebum. Stet clita kasd gubergren, no sea takimata sanctus est Lorem ipsum dolor sit amet. Lorem ipsum dolor sit amet, consetetur sadipscing.

Lorem ipsum dolor sit amet, consetetur sadipscing elitr, sed diam nonumy eirmod tempor invidunt ut labore et dolore magna aliquyam erat, sed diam voluptua.

$24.99 Lorem ipsum dolor sit amet. Order

Lorem ipsum dolor sit amet, consetetur sadipscing elitr, sed diam nonumy eirmod tempor invidunt ut labore et dolore magna aliquyam erat, sed diam voluptua.

$24.99 Lorem ipsum dolor sit amet. Order

15% off all items

Lorem ipsum dolor sit amet, consetetur sadipscing elitr, sed diam nonumy eirmod tempor invidunt ut labore et dolore magna aliquyam erat, sed diam voluptua.

SUBPAGE

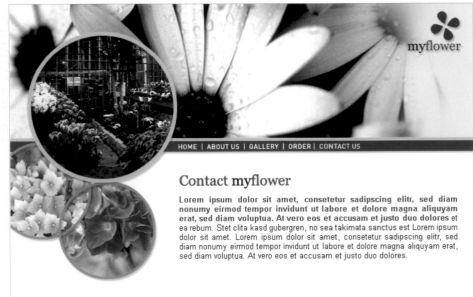

HOME | ABOUT US | GALLERY | ORDER | CONTACT US

Contact myflower

Lorem ipsum dolor sit amet, consetetur sadipscing elitr, sed diam nonumy eirmod tempor invidunt ut labore et dolore magna aliquyam erat, sed diam voluptua. At vero eos et accusam et justo duo dolores et ea rebum. Stet clita kasd gubergren, no sea takimata sanctus est Lorem ipsum dolor sit amet. Lorem ipsum dolor sit amet, consetetur sadipscing elitr, sed diam nonumy eirmod tempor invidunt ut labore et dolore magna aliquyam erat, sed diam voluptua. At vero eos et accusam et justo duo dolores.

POP-UP PAGE

CLOSE WINDOW

privacypolicies

Lorem ipsum dolor sit amet, consetetur sadipscing elitr, sed diam nonumy eirmod tempor invidunt ut labore et dolore magna aliquyam erat, sed diam voluptua. At vero eos et accusam et justo duo dolores et ea rebum. Stet clita kasd gubergren, no sea takimata sanctus est Lorem ipsum dolor sit Lorem ipsum dolor sit amet, consetetur sadipscing elitr, sed diam nonumy eirmod tempor invidunt ut labore et dolore magna aliquyam erat, sed diam voluptua. At vero eos et accusam et justo duo dolores et ea rebum. Stet clita kasd gubergren, no sea takimata sanctus est Lorem ipsum dolor sit amet. Lorem ipsum dolor sit amet, consetetur sadipscing elitr, sed diam nonumy eirmod tempor invidunt ut labore et dolore magna aliquyam erat, sed diam voluptua. At vero eos et accusam et justo duo dolores et ea rebum. Stet clita kasd gubergren, no sea takimata sanctus est Lorem ipsum dolor sit amet.

myflower

Welcome to myflower

Order myflower

Contact myflower

The typeface from the company's logo was used for the site's page titles. This gives the site a consistent, branded look.

Cascading Style Sheet (CSS)

```
BODY {
scrollbar-face-color: #FF0036;
scrollbar-highlight-color: #FB4C3F;
scrollbar-3dlight-color: #F32F20;
scrollbar-darkshadow-color: #8B021F;
scrollbar-shadow-color: #B80229;
scrollbar-arrow-color: #000000;
scrollbar-track-color: #EAD9DC;
}

TD {font-family: Arial, Verdana, Helvetica,
sans-serif; font-size: 13px; color: #000000; }

P {font-family: Arial, Verdana, Helvetica,
sans-serif; font-size: 13px; color: #000000; }

B {color: #FF0036; }

A:link {color: #FF0036; }
A:visited {color: #FF0036; }
A:hover {color: #000000; text-decoration: none; }
A:active {color: #FF0036; }

.Title {font-size: 16px; font-weight: bold; color: #FF0036; }
.SubTitle {font-size: 14px; }
.Footer {font-size: 9px; }
```

TIP: SAVING TO THE WEB

Images tend to fade and are less brilliant when viewed through browsers than in their original appearance on graphic authoring software. To counter this, bring up the color saturation and brightness levels on your images before saving your design to the Web.

STYLE 11
Color Harmony
Combinations That Work

As is true of any artistic endeavor, it is important that the colors on your Web site work well with one another and result in an aesthetically pleasing effect. Combining colors that don't overpower one another but, instead, create a visual balance is crucial to building a site where users are comfortable. The way your colors work together will greatly affect your overall design.

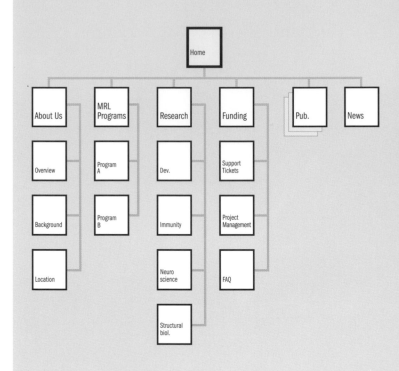

HOME PAGE

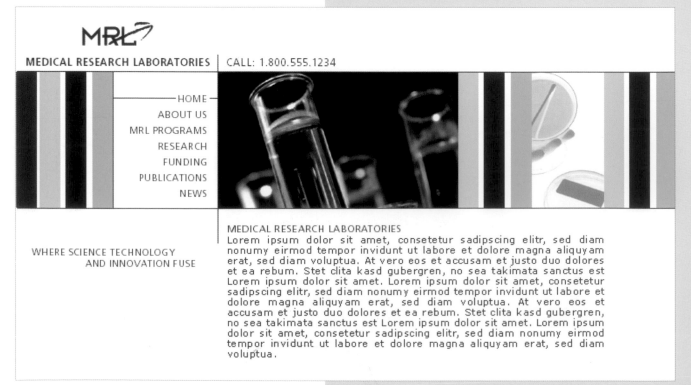

#525963

#A5D3DE

#005573

#42F3FF

#5F6352

#DED5A5

#736900

#FFC842

#635E52

#DEB7A5

#732C00

#FF6342

When deciding on colors for the various elements on your site, look to your logo or any other marketing materials that have already been produced. Use these as well as colors that complement them. If you have no existing marketing materials, think about the images you plan to use in your design and the colors that are prominent in them. A common technique designers employ to create a color scheme is to use colors from images that will appear on the site.

It is important to ensure sufficient contrast between the color of your text and the background color—an aesthetically pleasing site design is ineffective if users can't easily read the content. Other than this, feel free to be creative as you add and mix colors with various effects. Just keep in mind that your color scheme should represent the spirit of your company and that the colors should cooperate to produce a visually appealing site that users will enjoy viewing.

This chart shows the colors used on each page of the site. Though the colors vary by section, they nonetheless harmonize. This unusual technique keeps the site fresh and unique.

SUBPAGE

MEDICAL RESEARCH LABORATORIES | CALL: 1.800.555.1234

HOME
ABOUT US
MRL PROGRAMS
— RESEARCH —
FUNDING
PUBLICATIONS
NEWS

— DEVELOPMENT
IMMUNITY
NEUROSCIENCE
STRUCTURAL BIOL.

RESEARCH - DEVELOPMENT
Lorem ipsum dolor sit amet, consetetur sadipscing elitr, sed diam nonumy eirmod tempor invidunt ut labore et dolore magna aliquyam erat, sed diam voluptua. At vero eos et accusam et justo duo dolores et ea rebum. Stet clita kasd gubergren, no sea takimata sanctus est Lorem ipsum dolor sit amet. **Lorem ipsum dolor sit amet, consetetur sadipscing elitr, sed diam nonumy eirmod tempor invidunt ut labore et dolore magna aliquyam erat, sed diam voluptua.** At vero eos et accusam et justo duo dolores et ea rebum. Stet clita kasd gubergren, no sea takimata sanctus est Lorem ipsum dolor sit amet. Lorem ipsum dolor sit amet, consetetur sadipscing elitr, sed diam nonumy eirmod tempor invidunt ut labore et dolore magna aliquyam erat, sed diam voluptua.

SUBPAGE

MEDICAL RESEARCH LABORATORIES | CALL: 1.800.555.1234

HOME
ABOUT US
MRL PROGRAMS
RESEARCH
FUNDING
PUBLICATIONS
— NEWS —

WHERE SCIENCE TECHNOLOGY
AND INNOVATION FUSE

NEWS
Lorem ipsum dolor sit amet, consetetur sadipscing elitr, sed diam nonumy eirmod tempor invidunt ut labore et dolore magna aliquyam erat, sed diam voluptua.

June 12
At vero eos et accusam et justo duo dolores et ea rebum. Stet clita kasd gubergren, no sea takimata sanctus est Lorem ipsum dolor sit amet. Lorem ipsum dolor sit amet, consetetur sadipscing elitr, sed diam nonumy eirmod tempor invidunt ut labore et dolore magna aliquyam erat, sed diam voluptua. At vero eos et accusam et justo duo dolores et ea rebum. Stet clita kasd gubergren, no sea takimata sanctus est Lorem ipsum dolor sit amet. Lorem ipsum dolor sit amet, consetetur sadipscing elitr, sed diam nonumy eirmod tempor invidunt ut labore et dolore magna aliquyam erat, sed diam voluptua. At vero eos et accusam et justo duo dolores et ea rebum. Stet clita kasd gubergren, no sea takimata sanctus est Lorem ipsum dolor sit amet.

June 23
Duis autem vel eum iriure dolor in hendrerit in vulputate velit esse molestie consequat, vel illum dolore eu feugiat nulla facilisis at vero eros et accumsan et iusto odio dignissim qui blandit praesent luptatum zzril delenit augue duis dolore te feugait nulla facilisi. Lorem ipsum dolor sit amet, consectetuer adipiscing elit, sed diam nonummy nibh euismod tincidunt ut laoreet dolore magna aliquam erat volutpat.

June 25
Ut wisi enim ad minim veniam, quis nostrud exerci tation ullamcorper suscipit lobortis nisl ut aliquip ex ea commodo consequat. Duis autem vel eum iriure dolor in hendrerit in vulputate velit esse molestie consequat, vel illum dolore eu feugiat nulla facilisis at vero eros et accumsan et iusto odio dignissim qui blandit praesent luptatum zzril delenit augue duis dolore te feugait nulla facilisi.

POP-UP PAGE

CLOSE WINDOW

PROGRAM A - INDEX
Lorem ipsum dolor sit amet, consetetur sadipscing elitr, sed diam nonumy eirmod tempor invidunt ut labore et dolore magna aliquyam erat, sed diam voluptua. At vero eos et accusam et justo duo dolores et ea rebum. Stet clita kasd gubergren, no sea takimata sanctus est Lorem ipsum dolor sit amet. Lorem ipsum dolor sit amet, consetetur sadipscing elitr, sed diam nonumy eirmod tempor invidunt ut labore et dolore magna aliquyam erat, sed diam voluptua. At vero eos et accusam et justo duo dolores et ea rebum. Stet clita kasd gubergren, no sea takimata sanctus est Lorem ipsum dolor sit amet. Lorem ipsum dolor sit amet, consetetur sadipscing elitr, sed diam nonumy eirmod tempor invidunt ut labore et dolore magna aliquyam erat, sed diam voluptua. At vero eos et accusam et justo duo dolores et ea rebum. Stet clita kasd gubergren, no sea takimata sanctus est Lorem ipsum dolor sit amet.

Soluta nobis eleifend option congue nihil imperdiet doming id quod mazim placerat facer possim assum. Lorem ipsum dolor sit amet, consectetuer adipiscing elit, sed diam nonummy nibh euismod tincidunt ut laoreet dolore magna aliquam erat volutpat. uscipit lobortis nisl ut aliquip ex ea commodo consequat.

HOME
ABOUT US
MRL PROGRAMS
RESEARCH
FUNDING
PUBLICATIONS
NEWS

HOME
ABOUT US
MRL PROGRAMS
RESEARCH
FUNDING
PUBLICATIONS
NEWS

HOME
ABOUT US
MRL PROGRAMS
RESEARCH
FUNDING
PUBLICATIONS
NEWS

When users roll over the menu options, a line appears that extends through the chosen button. This is yet another method of differentiating the menu from the norm.

TIP: COLOR RESEARCH

It is crucial to spend time getting a sense of colors—that is, which ones do and don't work well together. Examine the color combinations in each section of this book. Try to understand why certain colors go well with one another and to figure out ways you can produce similarly pleasing results. Do the same with other books on color to build your comfort level with color harmony.

These black-and-white images were cropped before being used on the site. Black-and-white images tend to be more subtle, allowing for increased page balance and a less obtrusive effect. Using such images helps focus users on content while giving your site a rich, professional feel.

The images in the top right corner of each page were created in three steps. First, a base image was selected that was appropriate to the site.

Next, the image color was inverted to make it brighter and give it an innovative, cutting-edge effect.

Finally, the image was cropped to fit the desired space, and its opacity was reduced to 40 percent so it would not overpower the overall page design.

Cascading Style Sheet (CSS)

```
BODY {
scrollbar-face-color: #91A0A4;
scrollbar-highlight-color: #BCC2CA;
scrollbar-3dlight-color: #ACB1B9;
scrollbar-darkshadow-color: #525963;
scrollbar-shadow-color: #72767C;
scrollbar-arrow-color: #A5D3DE;
scrollbar-track-color: #A8BFC4;
}

TD {font-family: Verdana, Arial, Helvetica,
sans-serif; font-size: 11px; color: #005573; }

P {font-family: Verdana, Arial, Helvetica,
sans-serif; font-size: 11px; color: #005573; }

A:link {color: #004B65; }
A:visited {color: #004B65; }
A:hover {color: #005573; text-decoration: none; }
A:active {color: #005573; }

.Title {font-size: 12px; font-weight: bold; }
.Footer {font-size: 9px; }
```

STYLE 12
Simplicity in Design

Minimalist Approach

It is a myth that for a Web site to be worthwhile, it must utilize as many design techniques as possible. Some of the most interesting site designs are simple and understated. Though in some cases incorporating additional elements into a site is necessary, in many others an unobtrusive, uncluttered design is ideal.

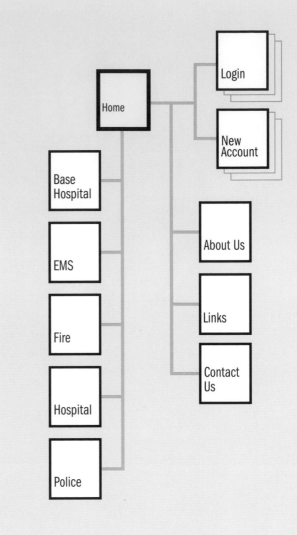

HOME PAGE

PHONE: 1.888.555.1234

basehospital.net

Home : About us : Links : Contact Us

Basehospital.net is a communication bridge to interactive websites which allows Paramedics, Fire Fighters, various Government and Regulatory Agencies to communicate and exchange Vital information, over the Internet, in **their own Private and Secure Area.**

LOGIN

CREATE NEW ACCOUNT

BASEHOSPITAL

EMS

FIRE

HOSPITAL

POLICE

A simple, straightforward site can be just as, if not more, effective than an elaborate, complex one. Subtle designs can be beneficial where a site features a large amount of content for users to sort through. Such a design will be easy to navigate and will help present the content clearly. A basic design can make finding information less difficult and the site itself more enjoyable for users to work with.

The pages on your site needn't be covered with images and animations in order to impress. As long as each page is well balanced with respect to color and contrast of elements so there is no unintended focus on any part of the screen, your site will appear professional.

As always, consider the type of Web site you wish to create. Having a straightforward site might be ideal for your purpose. Scores of major companies use understated, unobtrusive sites to represent their interests. Sometimes the most subtle design makes the greatest impact and often the best usability.

This company incorporated its Web address into the logo. This is an effective technique for Web-based businesses, especially where the Web name does not end with .com.

#E7E7F7
#CEC7E7
#EFF3E7
#CECF9C
#A56D31
#392894

As we see the layout of the boxes on the bare page, we understand the true simplicity of this site. In this case, it is important for the site to be straightforward and allow the user to access needed information immediately.

SUBPAGE

PHONE: 1.888.555.1234

Home : About us : Links : Contact Us

Basehospital.net is a communication bridge to interactive websites which allows Paramedics, Fire Fighters, various Government and Regulatory Agencies to communicate and exchange Vital information, over the Internet, in **their own Private and Secure Area.**

LOGIN

CREATE NEW ACCOUNT

About us

Lorem ipsum dolor sit amet, consetetur sadipscing elitr, sed diam nonumy eirmod tempor invidunt ut labore et dolore magna aliquyam erat, sed diam voluptua. At vero eos et accusam et justo duo dolores et ea rebum. Stet clita kasd gubergren, no sea takimata sanctus est Lorem ipsum dolor sit amet. Lorem ipsum dolor sit amet, consetetur sadipscing elitr, sed diam nonumy eirmod tempor invidunt ut labore et dolore magna aliquyam erat, sed diam voluptua.

At vero eos et accusam et justo duo dolores et ea rebum. Stet clita kasd gubergren, no sea takimata sanctus est Lorem ipsum dolor sit amet. Lorem ipsum dolor sit amet, consetetur sadipscing elitr, sed diam nonumy eirmod tempor invidunt ut labore et dolore magna aliquyam erat, sed diam voluptua.

Duis autem vel eum iriure dolor in hendrerit in vulputate velit esse molestie consequat, vel illum dolore eu feugiat nulla facilisis.

BASEHOSPITAL

EMS

FIRE

HOSPITAL

POLICE

SUBPAGE

PHONE: 1.888.555.1234

Home : About us : Links : Contact Us

Fire

Lorem ipsum dolor sit amet, consetetur sadipscing elitr, sed diam nonumy eirmod tempor invidunt ut labore et dolore magna voluptua. At vero eos et accusam et justo duo dolores et ea rebum. Stet clita kasd gubergren, no sea takimata sanctus est Lorem ipsum dolor sit amet. **Lorem ipsum dolor sit amet, consetetur sadipscing elitr, sed diam nonumy eirmod tempor invidunt ut labore** et dolore magna aliquyam erat, sed diam voluptua.

At vero eos et accusam et justo duo dolores et ea rebum. Stet clita kasd gubergren, no sea takimata sanctus est Lorem ipsum dolor sit amet. Lorem ipsum dolor sit amet, consetetur.

BASEHOSPITAL

EMS

FIRE

HOSPITAL

POLICE

POP-UP PAGE

Privacy**Policies**

Lorem ipsum dolor sit amet, consetetur sadipscing elitr, sed diam nonumy eirmod tempor invidunt ut labore et dolore magna aliquyam erat, sed diam voluptua. At vero eos et accusam et justo duo dolores et ea rebum. Stet clita kasd gubergren, no sea takimata sanctus est Lorem ipsum dolor sit Lorem ipsum dolor sit amet, consetetur sadipscing elitr, sed diam nonumy eirmod tempor invidunt ut labore et dolore magna aliquyam erat, sed diam voluptua. At vero eos et accusam et justo duo dolores et ea rebum. Stet clita kasd gubergren, no sea takimata sanctus est Lorem ipsum dolor sit amet. Lorem ipsum dolor sit amet, consetetur sadipscing elitr, sed diam nonumy eirmod tempor invidunt ut labore et dolore magna aliquyam erat, sed diam voluptua. At vero eos et accusam et justo duo dolores et ea rebum. Stet clita kasd gubergren, no sea takimata sanctus est Lorem ipsum dolor sit amet.

Cascading Style Sheet (CSS)

```
BODY {
scrollbar-face-color: #CCCC99;
scrollbar-arrow-color: #FFFFFF;
scrollbar-track-color: #EFF2E7;
}

TD {font-family: Verdana, Arial, Helvetica,
sans-serif; font-size: 12px; color: #996633; }

P {font-family: Verdana, Arial, Helvetica,
sans-serif; font-size: 12px; color: #996633; }

A:link {color: #835122; font-weight: bold; }
A:visited {color: #835122; font-weight: bold; }
A:hover {color: #B5773C; text-decoration: none; }
A:active {color: #B5773C; }

.Title {font-size: 15px; color: #996633; font-weight: bold; }
.SubTitle {font-size: 14px; color: #A46C34; font-weight: bold; }
.Footer {font-size: 10px; }
```

Web site designed for:

Base Hospital

www.basehospital.net

STYLE 13
Designing for Kids
Keeping It Fun

In certain circumstances, it may be necessary to design a Web site for children of a specific age group. You may be trying to sell a product to young people, educate them, or tell them about something new that is relevant to their lives. One always designs for a specific audience. When designing for kids, it is important to consider their specific requirements to ensure they will find your site both accessible and enjoyable.

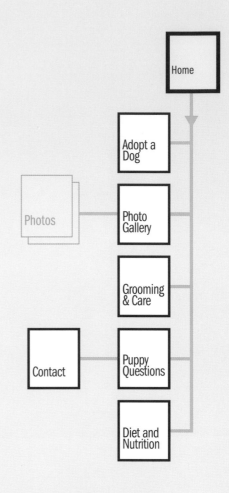

HOME PAGE

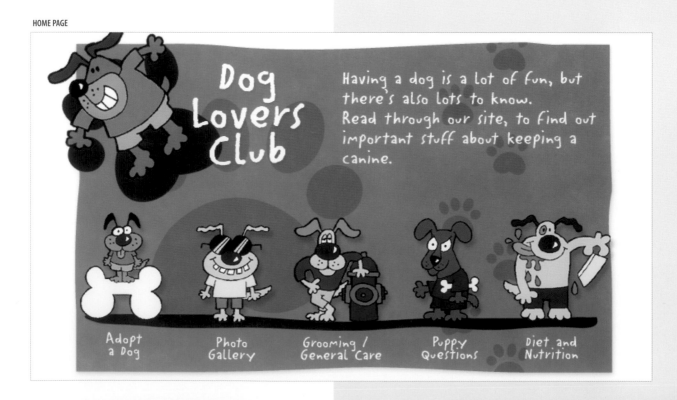

#FCEEE2

#DB751C

#B44611

#BF3F00

#7A0000

First, it is key to know the exact age group you are targeting. From this, you can determine the language and comprehension level of your audience. Don't bombard children with too much text—state what is necessary, but be concise and efficient. As is true of many adults, children don't want to read a lot of content—they want to hear what you have to say in a simple and succinct manner. When large bodies of text cannot be avoided, be sure to make these areas contained and easy to read.

Bright colors, large buttons, and oversized text may help keep interest in the site, depending on the age range targeted. Illustrations, animation, and sound can achieve the same end. But remember—children tend to be technically savvy and are often more comfortable with computers and the Internet than adults. Though your site should be simple and interesting, be sure not to patronize young users with too simple a design.

In general, have fun when designing for kids. Sites for children present an opportunity to be creative and to break from traditional design rules. As long as the site looks interesting and is easy to use, you can push the limits of conventional design.

SUBPAGE

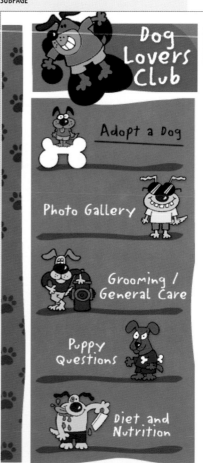

SUBPAGE

Dog Lovers Club

Photo Gallery

Adopt a Dog

Photo Gallery

Grooming / General Care

Puppy Questions

Diet and Nutrition

Lorem ipsum dolor sit amet, consetetur sadipscing elitr, sed diam nonumy eirmod tempor invidunt ut labore.

Lorem ipsum dolor sit amet, consetetur sadipscing elitr, sed diam nonumy eirmod tempor invidunt ut labore.

Lorem ipsum dolor sit amet, consetetur sadipscing elitr, sed diam nonumy eirmod tempor invidunt ut labore.

POP-UP PAGE

Shaquille – The Boxer

Close Window

Back | Next

These illustrations of dogs make the site fun, which encourages children to continue navigating. As they roll over each dog with their mouse, it wags its tail, adding interactivity to the initial effect. This makes the site enjoyable to use and potentially memorable to the young people browsing through.

SUBPAGE

Puppy Questions

Having a new puppy can sometimes be scary. We can answer any questions you may have, to help make sure they grow up fit and happy.

Lorem ipsum dolor sit amet, consetetur sadipscing elitr, sed diam nonumy eirmod tempor invidunt ut labore et dolore magna aliquyam erat, sed diam voluptua?

At vero eos et accusam et justo duo dolores et ea rebum. Stet clita kasd gubergren, no sea takimata sanctus est Lorem ipsum dolor sit amet. Lorem ipsum dolor sit amet, consetetur sadipscing elitr, sed diam nonumy eirmod tempor invidunt ut labore et dolore magna aliquyam erat, sed diam voluptua.

Lorem ipsum dolor sit amet, consetetur sadipscing elitr, sed diam nonumy eirmod tempor invidunt ut labore et dolore magna aliquyam erat, sed diam voluptua?

 At vero eos et accusam et justo duo dolores et ea rebum. Stet clita kasd gubergren, no sea takimata sanctus est Lorem ipsum dolor sit amet.

Duis autem vel eum iriure dolor in hendrerit in vulputate velit esse molestie consequat?

SUBPAGE

Grooming / General Care

Keeping a dog clean and trimmed is very important. Always be sure to wash, coif, and manicure your pup regularly, so they'll stay neat and healthy.

Lorem ipsum dolor sit amet, consetetur sadipscing elitr, sed diam nonumy eirmod tempor invidunt ut labore et dolore magna aliquyam erat, sed diam voluptua. At vero eos et accusam et justo duo dolores et ea rebum. Stet clita kasd gubergren, no sea takimata sanctus est Lorem ipsum dolor sit amet. Lorem ipsum dolor sit amet, consetetur sadipscing elitr, sed diam nonumy eirmod tempor invidunt ut labore et dolore magna aliquyam erat, sed diam voluptua. **Lorem ipsum dolor sit amet, consetetur sadipscing elitr, sed diam nonumy eirmod tempor invidunt ut labore et dolore magna aliquyam erat, sed diam voluptua.** At vero eos et accusam et justo duo dolores et ea rebum. Stet clita kasd gubergren, no sea takimata sanctus est Lorem ipsum dolor sit amet.

Duis autem vel eum iriure dolor in hendrerit in vulputate velit esse molestie consequat, vel illum dolore eu feugiat nulla facilisis at vero eros et accumsan et iusto odio dignissim qui blandit praesent luptatum zzril delenit augue duis dolore te feugait nulla facilisi. Lorem ipsum dolor sit amet, consectetuer adipiscing elit, sed diam nonummy nibh euismod tincidunt ut laoreet dolore magna aliquam erat volutpat.

Pawprints appear throughout the site in the background, sidelines, logo, and so on. This example of branding gives the site a carefree and playful feel.

Dog Lovers Club

Having a dog is a lot of fun, but there's also lots to know. Read through our site, to find out important stuff about keeping a canine.

The typeface for these titles looks like a child's handwriting. This feature enhances the easygoing flavor of the site and reinforces the existing branding.

Cascading Style Sheet (CSS)

```
BODY {
scrollbar-face-color: #E88733;
scrollbar-highlight-color: #DB751C;
scrollbar-3dlight-color: #BF3F00;
scrollbar-darkshadow-color: #DB751C;
scrollbar-shadow-color: #DB751C;
scrollbar-arrow-color: #B44611;
scrollbar-track-color: #F0D2B8;
}

TD {font-family: Verdana, Arial, Helvetica,
sans-serif; font-size: 14px; color: #7A0000; }

P {font-family: Verdana, Arial, Helvetica,
sans-serif; font-size: 14px; color: #7A0000; }

A:link {color: #7A0000; }
A:visited {color: #7A0000; }
A:hover {color: #BF3F00; text-decoration: none; }
A:active {color: #BF3F00; }

.Title {font-size: 14px; font-weight: bold; }
.Footer {font-size: 10px; }
```

STYLE 14
The Drop-Down Menu

Utilizing Space Effectively

The drop-down menu is a navigation system that allows you to condense many navigation options into a limited space. Originally used in software programs and operating systems, this technique is now commonly seen on the Web. As users roll over the menu, navigation selections drop down to reveal further options. This method is beneficial in that it conserves space, reduces visual clutter, and simplifies navigation by allowing all options to be presented at once in the same location.

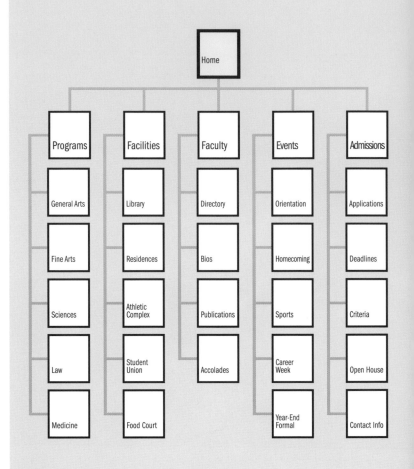

HOME PAGE

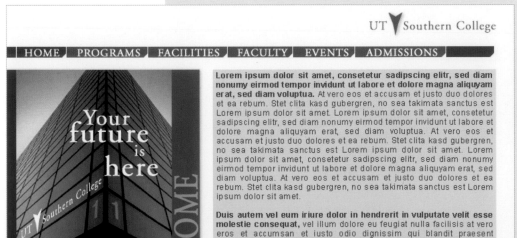

Drop-down menus are especially advantageous when a site has an abundance of navigation options and subcategories. A drop-down menu organizes the many options and presents them in a palatable format. If there are multiple levels of subcategories, each drop-down option can have its own drop-down subcategories, which in turn can have further suboptions if necessary. The drop-down format allows for compact, accessible navigation, no matter how large the site.

When using the drop-down method, it is a good idea to present the same main menu on each page of your site. As drop-down menus generally allow for navigation to any page on a site, offering a consistent menu structure throughout will make users comfortable as they click through.

There are, however, disadvantages to drop-down menus. They can be difficult to implement, and additional know-how is required to ensure they are compatible with all platforms and browsers. These considerations should be taken into account when deciding whether to utilize this navigation system. If you do choose to use drop-down menus, their benefits are clear, as they are a useful alternative that can help bring order and organization to a content-heavy site.

#EFF4FE

#D8DDE4

#ACB0B7

#516EAD

#3F588D

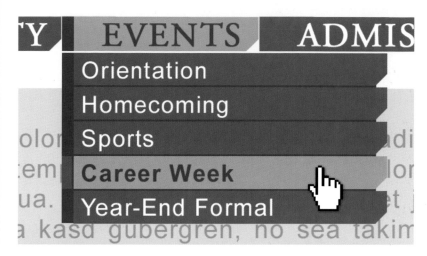

Here is a close-up of the main menu, with the Events option highlighted to indicate location in the site.

On rollover, the menu drops down, allowing users to select a suboption.

HOME PAGE

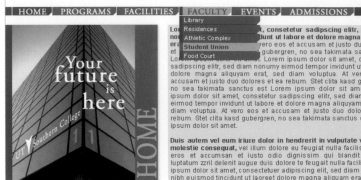

SUBPAGE

SUBPAGE

POP-UP PAGE

HOME PROGRAMS FACILITIES FACULTY EVENTS ADMISSIONS

The titles on this site were written vertically, bottom to top. This distinctive feature gives the site more play and offers a nice design element.

Cascading Style Sheet (CSS)

```
BODY {
scrollbar-face-color: #516EAD;
scrollbar-highlight-color: #7C97D1;
scrollbar-3dlight-color: #627FBE;
scrollbar-darkshadow-color: #344E87;
scrollbar-shadow-color: #425E9A;
scrollbar-arrow-color: #ACB0B7;
scrollbar-track-color: #D8DDE4;
}

TD {font-family: Arial, Verdana, Helvetica,
sans-serif; font-size: 12px; color: #504F4F; }

P {font-family: Arial, Verdana, Helvetica,
sans-serif; font-size: 12px; color: #504F4F; }

B {color: #3F588D; }

A:link {color: #3F588D; }
A:visited {color: #3F588D; }
A:hover {color: #3F588D; text-decoration: none; }
A:active {color: #3F588D; }

.Title {font-size: 15px; color: #3F588D; font-weight: bold; }
.SubTitle {font-size: 12px; color: #3F588D; font-weight: bold; }
.Footer {font-size: 10px; }
```

STYLE 15

Top and Side Navigation

Making Your Content Easily Accessible

Assuming you are designing for an English-speaking audience, users will be reading from left to right and top to bottom. This means you should display your navigation bar along the top of each page, along the left side, or in both locations, for ease of use.

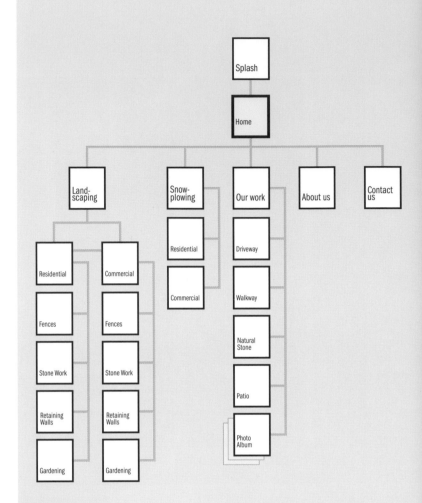

SPLASH PAGE

#EFFFFF
#CFDFCF
#E3ECA0
#7FB01F
#406F10
#62621C

Early Web designers thought that given the limited space across the top of a page, top navigation should be used in sites with fewer page links or shorter descriptors of page links, while side navigation was more appropriate for sites with many links or long descriptors. The current trend, however, is for main menus to be displayed across the top of the page. People seem to perceive top navigation as more aesthetically pleasing and easier to manage. Side navigation is still used, though generally for subnavigation purposes. In most cases, the main menu is displayed across the top of each page and side menus appear and change with the page and the subcategory.

To avoid confusing users, it is important that the side menu you display be consistent with the page it is on with respect to subject matter. Also, you should not give users side navigation options that lead to a different category altogether. Side navigation links should lead to subcategories within the subject area of the page being displayed.

Though top and side navigation is most common at present, other structures are certainly possible and viable. For example, you could use a top navigation bar for the main menu and a second navigation bar right below it for subnavigation. Alternatively, you could have a top navigation bar with drop-down menus that give users more options as they roll over a selection. Just remember: People are familiar with the conventional top and side structure. For users to be comfortable with your site and its navigation, you may be better off not reinventing the wheel.

DESIGN TEMPLATES: TOP AND SIDE NAVIGATION

SUBPAGE

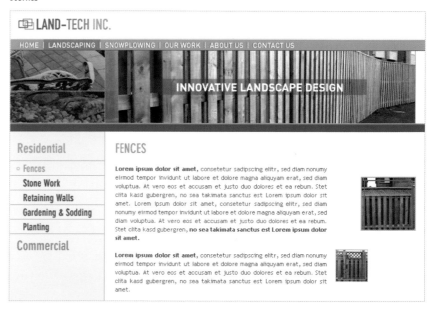

103

HOME PAGE

LAND-TECH INC.

LAND-TECH INC.

Lorem ipsum dolor sit amet, consetetur sadipscing elitr, sed diam nonumy eirmod tempor invidunt ut labore et dolore magna aliquyam erat, sed diam voluptua. At vero eos et accusam et justo duo dolores et ea rebum. Stet clita kasd gubergren, no sea takimata sanctus est Lorem ipsum dolor sit amet. Lorem ipsum dolor sit amet, consetetur sadipscing elitr, **sed diam nonumy eirmod tempor invidunt ut labore et dolore magna aliquyam erat, sed diam voluptua. At vero eos et accusam et justo duo dolores et ea rebum. Stet clita kasd gubergren, no sea takimata sanctus est Lorem ipsum dolor sit amet.**

Lorem ipsum dolor sit amet, consetetur sadipscing elitr, sed diam nonumy eirmod tempor invidunt ut labore et dolore magna aliquyam erat, sed diam voluptua. At vero eos et accusam et justo duo dolores et ea rebum. Stet clita kasd gubergren, no sea takimata sanctus est Lorem ipsum dolor sit amet. Duis autem vel eum iriure dolor in hendrerit in vulputate velit esse molestie consequat, vel illum dolore eu feugiat nulla facilisis at vero eros et accumsan **et iusto odio dignissim qui blandit praesent luptatum zzril** delenit augue duis dolore te feugait nulla facilisi. Lorem ipsum dolor sit amet, consectetuer adipiscing elit, sed diam nonummy nibh euismod tincidunt ut laoreet dolore magna aliquam erat volutpat.

SUBPAGE

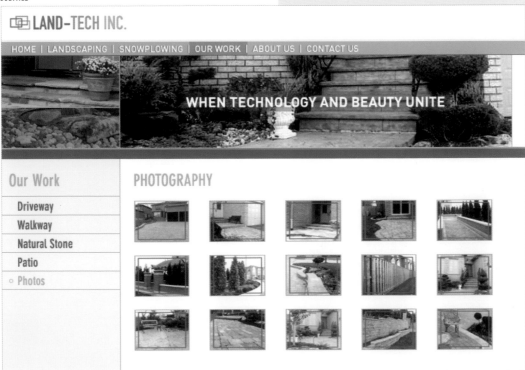

SUBPAGE

LAND-TECH INC.

PHONE: 1.800.555.1234

HOME | LANDSCAPING | SNOWPLOWING | OUR WORK | ABOUT US | CONTACT US

WHEN TECHNOLOGY AND BEAUTY UNITE

Residential
Commercial

LANDSCAPING

Lorem ipsum dolor sit amet, consetetur sadipscing elitr, sed diam nonumy eirmod tempor invidunt ut labore et dolore magna aliquyam erat, sed diam voluptua. At vero eos et accusam et justo duo dolores et ea rebum. Stet clita kasd gubergren, no sea takimata sanctus est Lorem ipsum dolor sit amet. Lorem ipsum dolor sit amet, consetetur sadipscing elitr, sed diam nonumy eirmod tempor invidunt ut labore et dolore magna aliquyam erat, sed diam voluptua. At vero eos et accusam et justo duo dolores et ea rebum. Stet clita kasd gubergren, no sea takimata sanctus est Lorem ipsum dolor sit amet.

Lorem ipsum dolor sit amet, consetetur sadipscing elitr, sed diam nonumy eirmod tempor invidunt ut labore et dolore magna aliquyam erat, sed diam voluptua. At vero eos et accusam et justo duo dolores et ea rebum. Stet clita kasd gubergren, no sea takimata sanctus est Lorem ipsum dolor sit amet.

POP-UP PAGE

CLOSE WINDOW

BACK | NEXT

105

Random images appear in the top left corner each time users arrive at a different page or return to a previous page. The examples shown are several possible images that can be displayed from the random cycle. Though subtle, this interesting technique enhances the overall appearance of the site.

Key areas within the larger image were cropped to yield smaller images, which are displayed on subpages of the site. This method allows for the creation of additional images when the number of original images available is limited.

Residential
Commercial

Residential

○ Fences

Stone Work

Retaining Walls

Gardening & Sodding

Planting

Commercial

This site uses top and side navigation. As a side navigation selection is chosen, it reveals more options.

Each page on the site contains a rectangular Flash movie that features a panoramic image of a landscape. Though we cannot see the entire image at once, the landscape moves across the frame so we can view it in its entirety.

Cascading Style Sheet (CSS)

```
BODY {
scrollbar-face-color: #7FB01F;
scrollbar-arrow-color: #FFFFFF;
scrollbar-track-color: #E3ECA0;
}

TD {font-family: Trebuchet MS, Verdana, Arial,
sans-serif; font-size: 12px; color: #406f10; }

P {font-family: Trebuchet MS, Verdana, Arial,
sans-serif; font-size: 12px; color: #406f10; }

A:link {color: #589E36; }
A:visited {color: #589E36; }
A:hover {color: #7FB01F; text-decoration: none; }
A:active {color: #7FB01F; }

.Title {font-size: 15px; font-weight: bold; }
.SubTitle {font-size: 14px; color: #589E36; }
.Footer {font-size: 9px; }
```

Web site designed for:

Land-Tech, Inc.

www.land-tech.ca

STYLE 16
Online Branding
Creating a Distinct Look

When you or your company decides to build a Web site, you clearly want to make an impression on users and have them perceive you in a specific way. Start-up companies in particular should consider public perception carefully, as a Web site may be the first chance for people to see who they are. The look of your site, in conjunction with other marketing materials, is vital in that it indefinitely affects how you will be thought of by the public. Relevant to these matters is the concept of *online branding*.

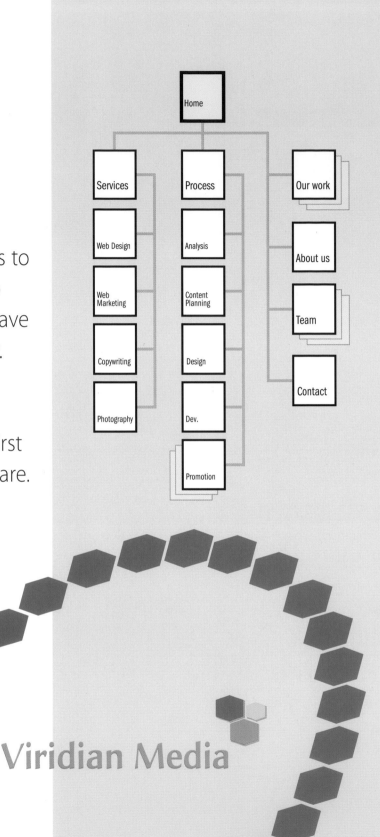

The company's logo was used as inspiration for the site's online branding. The design of each page is reminiscent of the logo.

#A9D3F9

#66B6ED

#2991EF

#3E408F

#8494AB

#FCD55D

Branding is the intended, strategic portrayal of a company through images, style, and overall design aspects. You should be aware of the importance of branding and keep it in mind throughout the design process. How you want to be perceived by the public is of the utmost concern.

You can research a wide variety of factors to help decide what type of brand you want and then to reinforce that brand on your site. Look at competitors' branding and see what you do and don't like about it and what has and hasn't worked. Think about your company image and what you'd like to express through your brand. Remember, the realm of conventionally acceptable Web sites offers plenty of room in which to be creative and distinguish yourself from the norm.

When thinking about a Web site, it is always a good idea to look at examples of branding that your company has already developed. To present a consistent look, draw on these materials as you formulate an online identity. For example, you could use the colors in your logo for backgrounds or even the overall color scheme for your site.

It is important to remember that people identify companies with their brands and that any alteration to branding could cause people to disassociate your brand from your organization. If your company already has branding in place, you should avoid altering that brand to fit a desired online design style. The critical decision to alter an existing brand should receive careful consideration given the potential effect on your business.

If you have decided to change your overall branding for your Web site or if you are a new company just starting out, remember to reflect the branding on your site in new letterhead, business cards, and so on. Be consistent in how you present yourself to the public. People think visually—they remember symbols, shapes, and colors above everything else. If your branding efforts have embedded your company's look in the minds of users, they will remember you, and your business will benefit as a result.

DESIGN TEMPLATES: ONLINE BRANDING

HOME PAGE

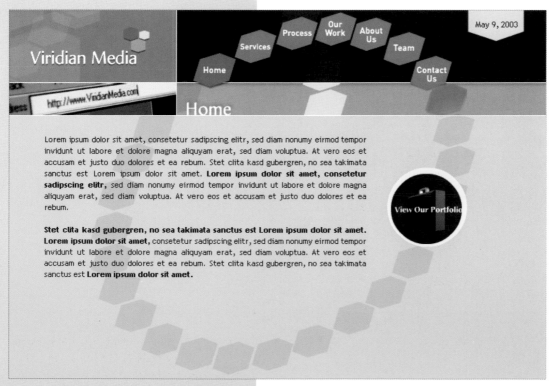

SUBPAGE

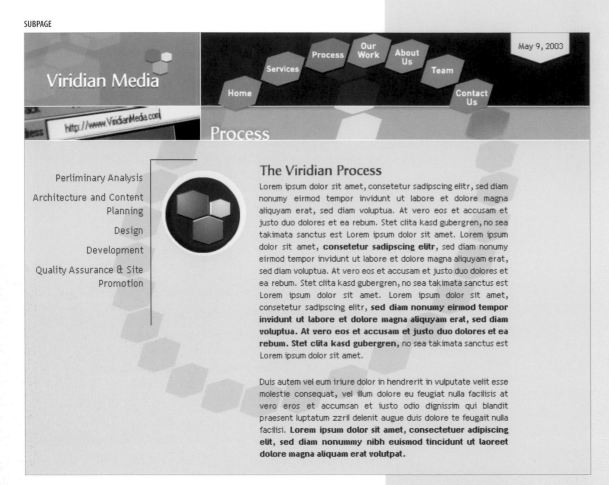

The Viridian Process

Lorem ipsum dolor sit amet, consetetur sadipscing elitr, sed diam nonumy eirmod tempor invidunt ut labore et dolore magna aliquyam erat, sed diam voluptua. At vero eos et accusam et justo duo dolores et ea rebum. Stet clita kasd gubergren, no sea takimata sanctus est Lorem ipsum dolor sit amet. Lorem ipsum dolor sit amet, **consetetur sadipscing elitr**, sed diam nonumy eirmod tempor invidunt ut labore et dolore magna aliquyam erat, sed diam voluptua. At vero eos et accusam et justo duo dolores et ea rebum. Stet clita kasd gubergren, no sea takimata sanctus est Lorem ipsum dolor sit amet. Lorem ipsum dolor sit amet, consetetur sadipscing elitr, **sed diam nonumy eirmod tempor invidunt ut labore et dolore magna aliquyam erat, sed diam voluptua. At vero eos et accusam et justo duo dolores et ea rebum. Stet clita kasd gubergren,** no sea takimata sanctus est Lorem ipsum dolor sit amet.

Duis autem vel eum iriure dolor in hendrerit in vulputate velit esse molestie consequat, vel illum dolore eu feugiat nulla facilisis at vero eros et accumsan et iusto odio dignissim qui blandit praesent luptatum zzril delenit augue duis dolore te feugait nulla facilisi. **Lorem ipsum dolor sit amet, consectetuer adipiscing elit, sed diam nonummy nibh euismod tincidunt ut laoreet dolore magna aliquam erat volutpat.**

SUBPAGE

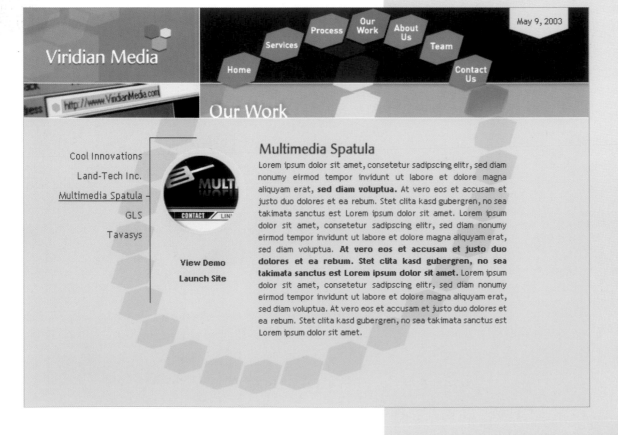

Multimedia Spatula

Lorem ipsum dolor sit amet, consetetur sadipscing elitr, sed diam nonumy eirmod tempor invidunt ut labore et dolore magna aliquyam erat, **sed diam voluptua.** At vero eos et accusam et justo duo dolores et ea rebum. Stet clita kasd gubergren, no sea takimata sanctus est Lorem ipsum dolor sit amet. Lorem ipsum dolor sit amet, consetetur sadipscing elitr, sed diam nonumy eirmod tempor invidunt ut labore et dolore magna aliquyam erat, sed diam voluptua. **At vero eos et accusam et justo duo dolores et ea rebum. Stet clita kasd gubergren, no sea takimata sanctus est Lorem ipsum dolor sit amet.** Lorem ipsum dolor sit amet, consetetur sadipscing elitr, sed diam nonumy eirmod tempor invidunt ut labore et dolore magna aliquyam erat, sed diam voluptua. At vero eos et accusam et justo duo dolores et ea rebum. Stet clita kasd gubergren, no sea takimata sanctus est Lorem ipsum dolor sit amet.

POP-UP PAGE

PRIVACY POLICY

Lorem ipsum dolor sit amet, consetetur sadipscing elitr, sed diam nonumy eirmod tempor invidunt ut labore et dolore magna aliquyam erat, sed diam voluptua. At vero eos et accusam et justo duo dolores et ea rebum. Stet clita kasd gubergren, no sea takimata sanctus est Lorem ipsum dolor sit amet. Lorem ipsum dolor sit amet, consetetur sadipscing elitr, sed diam nonumy eirmod tempor invidunt ut labore et dolore magna aliquyam erat, sed diam voluptua. At vero eos et accusam et justo duo dolores et ea rebum. Stet clita kasd gubergren, no sea takimata sanctus est Lorem ipsum dolor sit amet. Lorem ipsum dolor sit amet, consetetur sadipscing elitr, sed diam nonumy eirmod tempor invidunt ut labore et dolore magna aliquyam erat, sed diam voluptua. At vero eos et accusam et justo duo dolores et ea rebum. Stet clita kasd gubergren, no sea takimata sanctus est Lorem ipsum dolor sit amet.

Close Window

Each page of the site contains a rectangle with a Flash movie of the name of the site being typed into a browser. This detail is both visually stimulating and promotional in that it reminds users of the site's address and the name of the company.

The date, the shape of which reflects the company logo, is featured on each page of the site. Displaying the date is an effective way to show users the site is current.

Cascading Style Sheet (CSS)

```
BODY {
scrollbar-face-color: #8CB8EC;
scrollbar-highlight-color: #9CC3F7;
scrollbar-3dlight-color: #538BCC;
scrollbar-darkshadow-color: #538BCC;
scrollbar-shadow-color: #1A4B85;
scrollbar-arrow-color: #E4ECF6;
scrollbar-track-color: #878AA1;
}

TD {font-family: Trebuchet MS, Verdana, Arial,
sans-serif; font-size: 12px; color: #3E408F; }

P {font-family: Trebuchet MS, Verdana, Arial,
sans-serif; font-size: 12px; color: #3E408F; }

A:link {color: #928C07; }
A:visited {color: #63688E; }
A:hover {color: #3E408F; }
A:active {color: #666666; }

.Title {font-size: 16px; color: #202980; font-weight: bold; }
.Footer {font-size: 10px; }
```

Web site designed for:

Viridian Media
www.viridianmedia.com

STYLE 17
Creative Marketing
Strategic Promotion and Product Placement

The Internet provides an excellent opportunity to be creative in the marketing of your business or product. If you've managed to get a user to visit your site, you should take the opportunity to wow them and tell them as much as you possibly can about who you are and what you do. People often comparison shop on the Web, as it is the easiest way to get the most information about a number of companies. Knowing this, you should do everything you can to impress users and to differentiate yourself from the other sites they've seen.

Basic to marketing is ensuring users know what your company is about and what it sells. Display your product and logo prominently within your site's design. Use special promotions and banner ads to add flair and grab attention. A Flash presentation is an excellent way to illustrate what your product does or to draw attention to it within the context of a page. Do what you can to make your product appealing to users and to make your site stand out in their minds.

Key to any marketing effort are promotional images that show what your product does. Yet, it is also important to display images of the product itself throughout the site. For example, designers of a kitchenware site might want to show visuals of people cooking, but should nonetheless feature close-up images of just the kitchenware products themselves in order to be effective. Using this method, people will become familiar with your product and will be more likely to purchase it. Strategic product placement throughout a site is another useful tactic. This technique involves placing images of the product on the page in such a way as to emphasize their importance.

Even where the product is intangible or visually unimpressive, it is important to show users an image that can be associated with it. For example, if you feel it futile to show pictures of a disk when selling a software program, you can show screen captures from the program itself. People want to see what they are buying. Be sure to give them a visual memory of the product that will stay with them when they leave your site.

Aside from these few basic points, how you choose to market your product is up to you, and the best ways to do that vary from industry to industry. Remember, be creative and try to distinguish yourself from the crowd. Testimonials, frequently asked questions (FAQs), and information bubbles are good ways to make your site stand out. Marketing a product is always difficult, but the endless possibilities available on the Web make the job easier.

#D2D7A0
#B4BC61
#D8AE01
#474D03

A Flash presentation on your home page is a good way to promote and market more than one product. Here are three frames from a Flash movie.

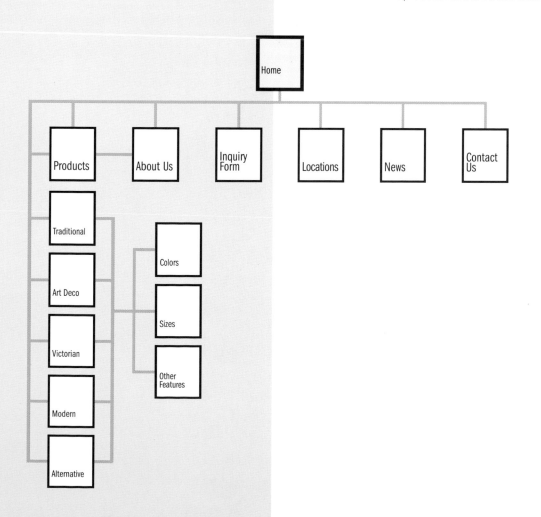

HOME PAGE

InfinitiLamp

HOME : PRODUCTS : ABOUT US : INQUIRY FORM : LOCATIONS : NEWS : CONTACT US

Lighting Up Your Life

Infiniti Styles:

Traditional
Art Deco
Victorian
Modern
Alternative

TraditionalStyle

THE LIGHTER SIDE OF LAMPS

Lorem ipsum dolor sit amet, consetetur sadipscing elitr, sed diam nonumy eirmod tempor invidunt ut labore et dolore magna aliquyam erat, sed diam voluptua. At vero eos et accusam et justo duo dolores et ea rebum. Stet clita kasd gubergren, no sea takimata sanctus est Lorem ipsum dolor sit amet. Lorem ipsum dolor sit amet, consetetur sadipscing elitr, sed diam nonumy eirmod tempor invidunt ut labore et dolore magna aliquyam erat, sed diam voluptua. At vero eos et accusam et justo duo dolores et ea rebum. **Stet clita kasd gubergren, no sea takimata sanctus est Lorem ipsum dolor sit amet. Lorem ipsum dolor sit amet, consetetur sadipscing elitr, sed diam nonumy eirmod tempor invidunt ut labore et dolore magna aliquyam erat, sed diam voluptua.** At vero eos et accusam et justo duo dolores et ea rebum. Stet clita kasd gubergren, no sea takimata sanctus est Lorem ipsum dolor sit amet.

NEWS:

May 03
Lorem ipsum dolor sit amet, consetetur sadipscing elitr, sed diam nonumy eirmod tempor invidunt ut labore et dolore magna aliquyam erat, sed diam voluptua.

May 26
At vero eos et accusam et justo duo dolores et ea rebum. Stet clita kasd gubergren, no sea takimata sanctus est Lorem ipsum dolor sit amet.

SUBPAGE

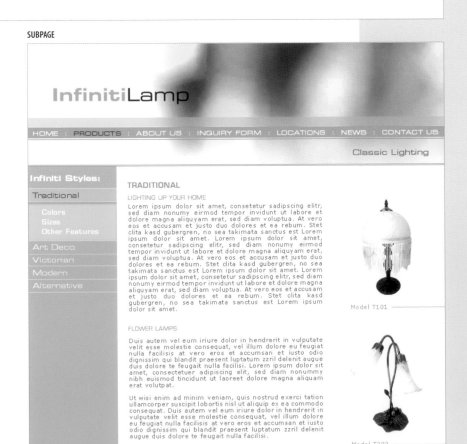

InfinitiLamp

HOME : PRODUCTS : ABOUT US : INQUIRY FORM : LOCATIONS : NEWS : CONTACT US

Classic Lighting

Infiniti Styles:

Traditional
 Colors
 Sizes
 Other Features
Art Deco
Victorian
Modern
Alternative

TRADITIONAL

LIGHTING UP YOUR HOME

Lorem ipsum dolor sit amet, consetetur sadipscing elitr, sed diam nonumy eirmod tempor invidunt ut labore et dolore magna aliquyam erat, sed diam voluptua. At vero eos et accusam et justo duo dolores et ea rebum. Stet clita kasd gubergren, no sea takimata sanctus est Lorem ipsum dolor sit amet. Lorem ipsum dolor sit amet, consetetur sadipscing elitr, sed diam nonumy eirmod tempor invidunt ut labore et dolore magna aliquyam erat, sed diam voluptua. At vero eos et accusam et justo duo dolores et ea rebum. Stet clita kasd gubergren, no sea takimata sanctus est Lorem ipsum dolor sit amet. Lorem ipsum dolor sit amet, consetetur sadipscing elitr, sed diam nonumy eirmod tempor invidunt ut labore et dolore magna aliquyam erat, sed diam voluptua. At vero eos et accusam et justo duo dolores et ea rebum. Stet clita kasd gubergren, no sea takimata sanctus est Lorem ipsum dolor sit amet.

Model T101

FLOWER LAMPS

Duis autem vel eum iriure dolor in hendrerit in vulputate velit esse molestie consequat, vel illum dolore eu feugiat nulla facilisis at vero eros et accumsan et iusto odio dignissim qui blandit praesent luptatum zzril delenit augue duis dolore te feugait nulla facilisi. Lorem ipsum dolor sit amet, consectetuer adipiscing elit, sed diam nonummy nibh euismod tincidunt ut laoreet dolore magna aliquam erat volutpat.

Ut wisi enim ad minim veniam, quis nostrud exerci tation ullamcorper suscipit lobortis nisl ut aliquip ex ea commodo consequat. Duis autem vel eum iriure dolor in hendrerit in vulputate velit esse molestie consequat, vel illum dolore eu feugiat nulla facilisis at vero eros et accumsan et iusto odio dignissim qui blandit praesent luptatum zzril delenit augue duis dolore te feugait nulla facilisi.

Model T202

114

SUBPAGE

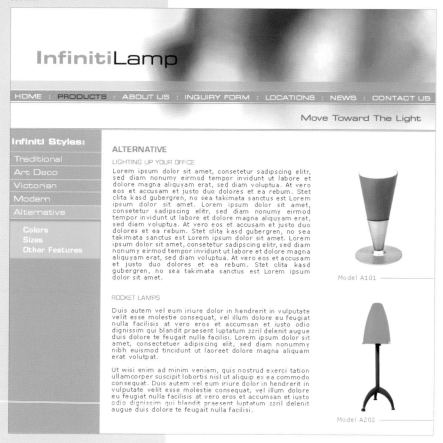

POP-UP PAGE

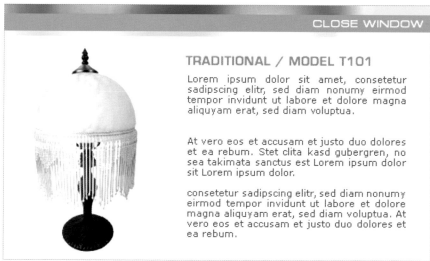

As users click on a product, a pop-up window appears that provides details: a description of the model, type, and so on. Such features are effective marketing tools.

Lighting Up Your Life

Move Toward The Light

Classic Lighting

Each page features a different catch-phrase at the top. This is a good way to get users' attention and further promote your product.

Infiniti Styles:

Traditional

Art Deco

Victorian

Modern

Alternative

Though users can obtain product information through the Products page, they can also access such material from the home page through the Styles menu on the side. This approach is beneficial in that it doubles the number of ways in which users can access information.

This vibrant, colorful image appears at the top of each page. Abstract images such as this one can give users a feel for your company without being overbearing.

DESIGN TEMPLATES: CREATIVE MARKETING

Cascading Style Sheet (CSS)

```
BODY {
scrollbar-face-color: #D8AE01;
scrollbar-highlight-color: #E4BB15;
scrollbar-3dlight-color: #E9CB10;
scrollbar-darkshadow-color: #A28C03;
scrollbar-shadow-color: #C4AA05;
scrollbar-arrow-color: #D2D7A0;
scrollbar-track-color: #D2D7A0;
}

TD {font-family: Verdana, Arial, Helvetica,
sans-serif; font-size: 11px; color: #666A75; }

P {font-family: Verdana, Arial, Helvetica,
sans-serif; font-size: 11px; color: #666A75; }

B {color: #BE9900; }

A:link {color: #BE9900; }
A:visited {color: #BE9900; }
A:hover {color: #474D03; text-decoration: none; }
A:active {color: #474D03; }

.Title {font-size: 14px; color: #BE9900; font-weight: bold; }
.SubTitle {font-size: 12px; color: #BE9900; font-weight: bold; }
.Footer {font-size: 10px; }
```

STYLE 18
Using Flash
Enticing Users with Visuals

Macromedia Flash is an animation tool that lets you set your site in motion, which is more exciting than still pictures, either on its own or through interaction with users. Flash allows you to show actual movement, which can be especially important if change or progress is an important aspect of your company. Despite their benefits, you must ensure that Flash elements do not overwhelm users and detract from the content of your site. Used properly, Flash can give your site a visually appealing, technologically savvy look.

Flash can be an exciting, interactive addition to your site or used to build your site completely. It uses vector graphics that allow complex animations to download quickly. It is versatile and can be easily incorporated into almost any site.

A Flash movie can be used within an HTML page to allow part or all of your site to be animated. In addition to adding flair to the site, the Flash elements can draw attention to certain parts of the screen, thereby focusing users on what you want them to see. Also, if you are trying to save space, Flash elements can present multiple images in the same spot. For example, you can present an entire product line in one box by creating a successive loop of product images.

Flash is more than just another technology; if used effectively, its marketing benefits are almost limitless. Even Flash Intro can be an excellent presentation tool that generates interest in your site. Introducing your product or company with an impressive Flash presentation can be enough to bring in users and improve your overall image.

HOME PAGE

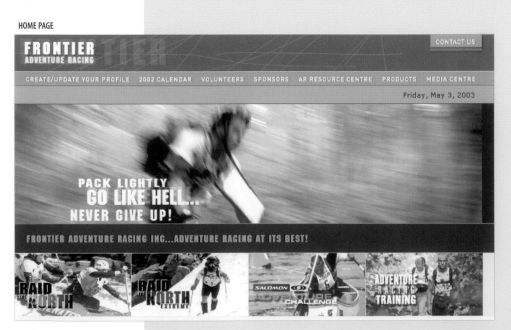

118

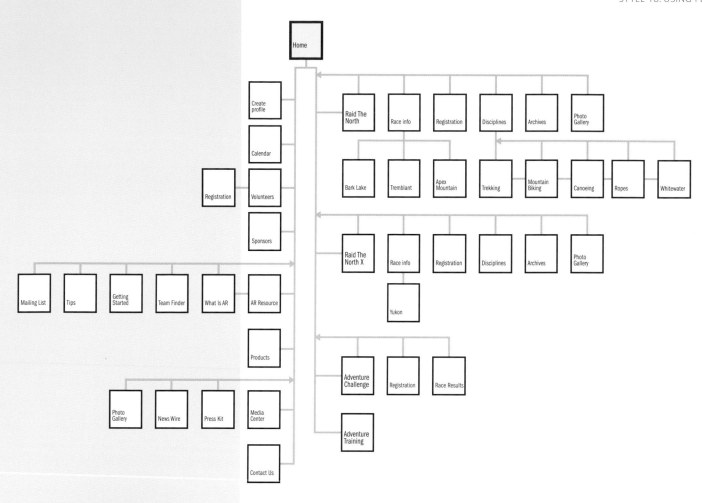

Home

Create profile

Calendar

Registration

Volunteers

Sponsors

Mailing List

Tips

Getting Started

Team Finder

What Is AR

AR Resource

Products

Photo Gallery

News Wire

Press Kit

Media Center

Contact Us

Raid The North

Race info

Registration

Disciplines

Archives

Photo Gallery

Bark Lake

Tremblant

Apex Mountain

Trekking

Mountain Biking

Canoeing

Ropes

Whitewater

Raid The North X

Race info

Registration

Disciplines

Archives

Photo Gallery

Yukon

Adventure Challenge

Registration

Race Results

Adventure Training

#EFDFB0

#E7AE00

#A5A608

#928C07

#A63C08

#736D5A

PACK LIGHTLY
GO LIKE HELL...
NEVER GIVE UP!

Adventure is not only hanging on a rope on the side of a mountain. Adventure is an attitude that we must apply to every part of our lives. Facing new challenges, seizing new opportunities, testing our resources against the unknown and unpredictable and in the process discovering our own unique potential.

These three images form the home page Flash animation. More impressive than a static image, the Flash movie simulates movement and thus conveys the excitement of cycling this adventure company wants to present. During the animation, a catchphrase is superimposed on the images, followed by a sentence that looks like it is being typed.

SUBPAGE

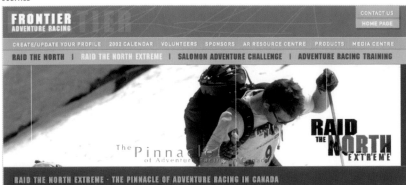

SUBPAGE

CONTACT US

CONTACT US
HOME PAGE

Each page includes a Contact Us link. Pages other than the home page also feature a Home Page link below the Contact Us link.

POP-UP PAGE

PRIVACY POLICY

Lorem ipsum dolor sit amet, consetetur sadipscing elitr, sed diam nonumy eirmod tempor invidunt ut labore et dolore magna aliquyam erat, sed diam voluptua. At vero eos et accusam et justo duo dolores et ea rebum. Stet clita kasd gubergren, no sea takimata sanctus est Lorem ipsum dolor sit amet. Lorem ipsum dolor sit amet, consetetur sadipscing elitr, sed diam nonumy eirmod tempor invidunt ut labore et dolore magna aliquyam erat, sed diam voluptua. At vero eos et accusam et justo duo dolores et ea rebum. Stet clita kasd gubergren, no sea takimata sanctus est Lorem ipsum dolor sit amet. Lorem ipsum dolor sit amet, consetetur sadipscing elitr, sed diam nonumy eirmod tempor invidunt ut labore et dolore magna aliquyam erat, sed diam voluptua. At vero eos et accusam et justo duo dolores et ea rebum. Stet clita kasd gubergren, no sea takimata sanctus est Lorem ipsum dolor sit amet.

CLOSE

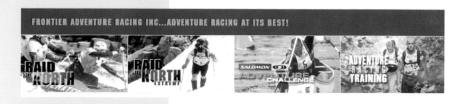

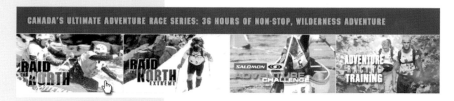

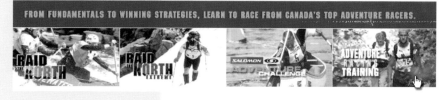

As users roll over the main menu buttons, the images change color, move slightly, and text appears above, outlining the options. This was produced with JavaScript.

Cascading Style Sheet (CSS)

```
BODY {
scrollbar-face-color: #A5A608;
scrollbar-highlight-color: #FFF77B;
scrollbar-shadow-color: #928C07;
scrollbar-arrow-color: #E6E767;
scrollbar-track-color: #FFFFCE;
}

TD {font-family: Verdana, Arial, Helvetica,
sans-serif; font-size: 12px; color: #990000; }

P {font-family: Verdana, Arial, Helvetica,
sans-serif; font-size: 12px; color: #990000; }

A:link {color: #928C07; }
A:visited {color: #928C07; }
A:hover {color: #666666; }
A:active {color: #666666; }
.Title {font-size: 16px; color: #F9A11B; font-weight: bold; }
.Footer {font-size: 10px; }
```

TIP: USING SOUND

Though Flash allows for the use of sound,
it is advisable to use sound sparingly. Repetitive sounds can be annoying, and loud, sharp noises upsetting. If you choose to use sound effects, be sure they are subtle or pleasing and will not overwhelm users. Always give users the option to turn off background music and other sound effects.

Web site designed for:

Frontier Adventure Racing, Inc.

www.raidthenorth.com

STYLE 19

Web Interactivity

Involving Your Audience

Interactivity is the process by which an audience actively participates in the viewing of your Web site. It is your job, as a Web designer, to communicate a strong, clearly presented message, while it is up to users to interpret that message and to make choices about where they want to go and what they want to do. Strategically and cleverly deployed, user interaction opportunities can be an extremely beneficial aspect of a site.

User interactions occur on three main levels:

1. Basic navigation through a site structure

2. More specific forms of interactivity—chat rooms, purchase forms, sign-up sheets, questionnaires, and so on

3. More subtle forms of Web interactivity, described for our purposes as interest interactivity—menu options that change color when rolled over, interactive presentations that allow users to personalize a product, and so on

Interest interactivity, the third level, is used to emphasize specific aspects of either page design or content. The menu option that changes color when users roll over it draws attention to the action they just took. An interactive presentation wherein users select features to personalize a product—for example, when a car company allows users to build their own car with individually selected, customized features—emphasizes the flexibility and features of that product.

HOME PAGE

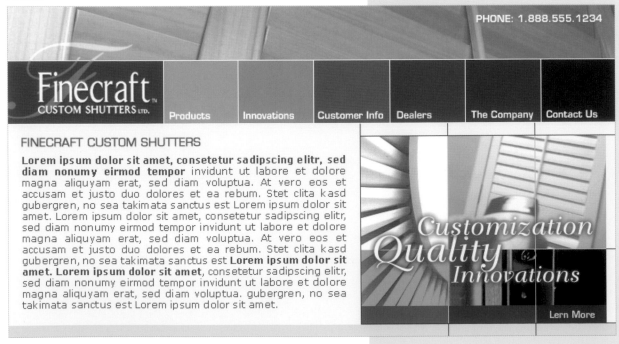

#FFE3BD
#F7CFAD
#D65118
#F7A242
#F79231
#F76129
#D64900
#BD4100
#943000

Interest interactivity can add considerably to the overall usability of your site. One way to achieve this is with Flash animation. Flash navigation can be implemented whereby users see a Flash movie explaining an option each time they roll over a menu selection. This will help clarify the options and assist users in navigating further.

Though interactivity with users can be beneficial, it is not always so. Interactivity can be ineffective or even detrimental to your site. An example of a good use of interactivity is a logo that animates when users roll over it. This subtle technique causes users to interact with the logo and, thus, helps them remember both the logo and the company. An example of detrimental interactivity is an Intro that ends with the message Click Here to Enter the Site. Such a feature forces users to choose an option they have already chosen by visiting the site or allows them the opportunity to leave the site when they would otherwise have waited to navigate further.

Strategically applied interactivity can be a powerful tool. Think in advance about how users will view your site and what features you could add to enhance its appeal. Good interactive features on a Web site imply both the designer and the company are creative and technologically savvy.

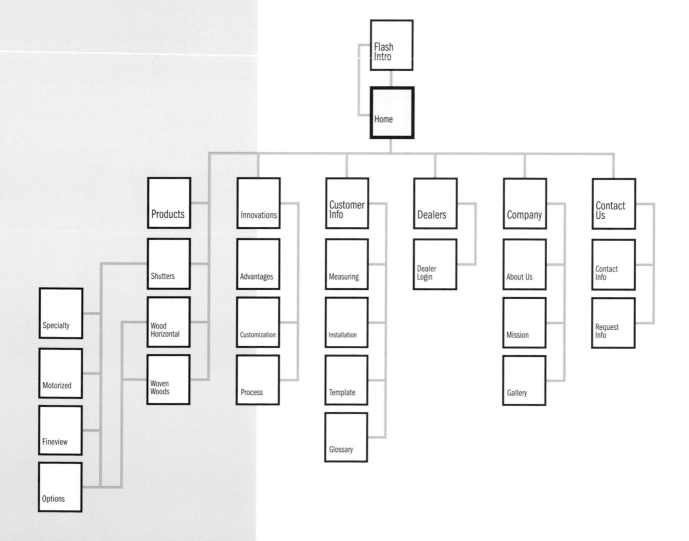

SUBPAGE

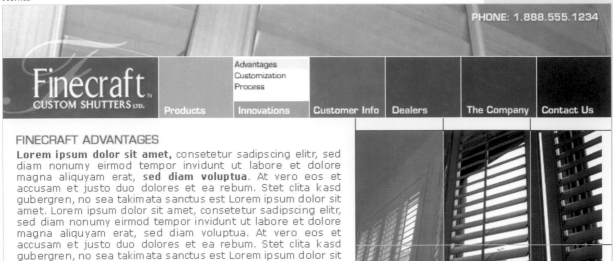

FINECRAFT ADVANTAGES

Lorem ipsum dolor sit amet, consetetur sadipscing elitr, sed diam nonumy eirmod tempor invidunt ut labore et dolore magna aliquyam erat, **sed diam voluptua.** At vero eos et accusam et justo duo dolores et ea rebum. Stet clita kasd gubergren, no sea takimata sanctus est Lorem ipsum dolor sit amet. Lorem ipsum dolor sit amet, consetetur sadipscing elitr, sed diam nonumy eirmod tempor invidunt ut labore et dolore magna aliquyam erat, sed diam voluptua. At vero eos et accusam et justo duo dolores et ea rebum. Stet clita kasd gubergren, no sea takimata sanctus est Lorem ipsum dolor sit amet. Lorem ipsum dolor sit amet, consetetur sadipscing elitr, sed diam nonumy eirmod tempor invidunt ut labore et dolore magna aliquyam erat, sed diam voluptua. **gubergren, no sea takimata sanctus est Lorem ipsum dolor sit amet.**

SUBPAGE

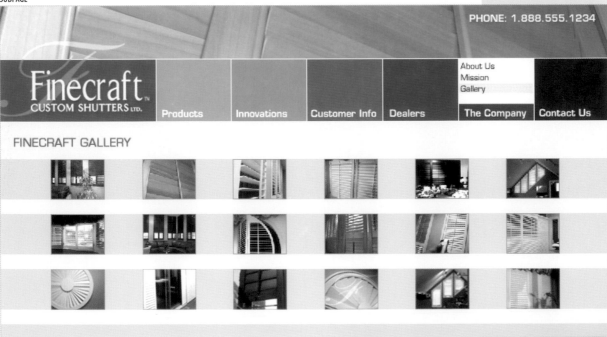

FINECRAFT GALLERY

POP-UP PAGE

PRIVACY POLICIES

Lorem ipsum dolor sit amet, consetetur sadipscing elitr, sed diam nonumy eirmod tempor invidunt ut labore et dolore magna aliquyam erat, sed diam voluptua. At vero eos et accusam et justo duo dolores et ea rebum. Stet clita kasd gubergren, no sea takimata sanctus est Lorem ipsum dolor sit Lorem ipsum dolor sit amet, consetetur sadipscing elitr, sed diam nonumy eirmod tempor invidunt ut labore et dolore magna aliquyam erat, sed diam voluptua. At vero eos et accusam et justo duo dolores et ea rebum. Stet clita kasd gubergren, no sea takimata sanctus est Lorem ipsum dolor sit amet. Lorem ipsum dolor sit amet, consetetur sadipscing elitr, sed diam nonumy eirmod tempor invidunt ut labore et dolore magna aliquyam erat, sed diam voluptua. At vero eos et accusam et justo duo dolores et ea rebum. Stet clita kasd gubergren, no sea takimata sanctus est Lorem ipsum dolor sit amet.

GALLERY POP UP PAGE

GALLERY POP UP PAGE

The Flash Intro for this site features images that highlight the design of various types of shutters. This animation emphasizes the custom-made aspect of the products, a characteristic the company wants to stress.

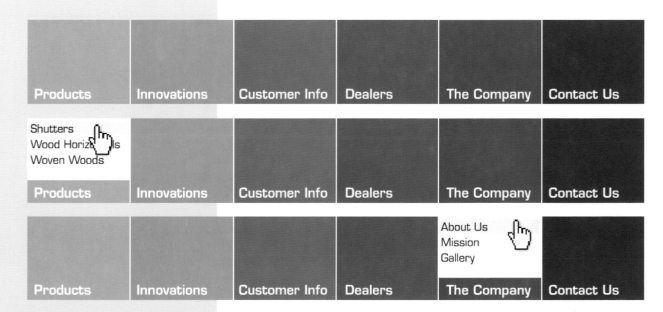

As users click on a catergory, they interact with the Flash navigation. Additional options appear in a format reminiscent of a shutter opening. This is both eye-catching and appropriate for the site of a shutter company.

On each of the product pages, as users roll over the numbers at the bottom of an image, a different image of that product appears. The various angles and distances give users a better sense of what the product truly looks like. The images are designed so it seems as if the products are being viewed through a window—again, appropriate for this custom shutter company.

Cascading Style Sheet (CSS)

```
TD {font-family: Verdana, Arial, Helvetica,
sans-serif; font-size: 12px; color: #CE4106; }

P {font-family: Verdana, Arial, Helvetica,
sans-serif; font-size: 12px; color: #CE4106; }

A:link {color: #903000; }
A:visited {color: #903000; }
A:hover {color: #CE4106; text-decoration: none; }
A:active {color: #CE4106; }

.Title {font-size: 14px; font-weight: bold; }
.SubTitle {font-size: 13px; }
.Footer {font-size: 9px; }
```

Web site designed for:

Finecraft Custom Shutters Ltd.

www.finecraftshutters.com

STYLE 20
The Photo Album

Displaying Images

Quite often, a Web site will call for the visual representation of a person or product to showcase the individual or business. To this end, a photo album or gallery can be used. A gallery can constitute an entire site or be a subcategory within a larger site structure. Such a feature allows for the display of numerous photographs, giving users a fuller sense of the product or service being sold.

| #FDC893 |
| #F7E700 |
| #B01D43 |
| #801332 |

HOME PAGE

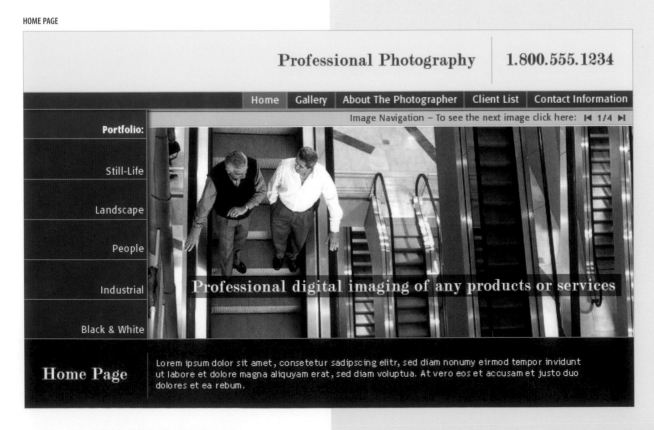

Whether your entire site is a photo gallery or the gallery is just a part of your overall design, it is a good idea to offer an index of images and a means for users to keep track of where they are in the album. Photo albums can be confusing. In an attempt to focus users entirely on the images, they tend to contain no text or navigation options. Be sure to organize your album clearly. It is not effective to display beautiful visuals if users become confused and are unable to navigate through them easily.

With respect to organization, many effective methods can be employed. You could present a list of topics on the side of each page or display thumbnails (small versions) of the images that, when clicked, reveal the image at full size. Any form of organization that presents your gallery clearly will make the viewing experience more enjoyable for users and encourage them to stay at your site longer.

Ensure that users viewing a particular image have the option to go to the next image or back to the previous image. This way, they are not forced to return to the main menu after each image they view. To facilitate this method, a feature showing how many images have been viewed and how many are left (for example, < 7/9 >) is helpful.

Of course, make sure your images are attractive and present your product in the best possible light. To the extent you are able, sell your product or service with your images, using them as a strategic marketing tool.

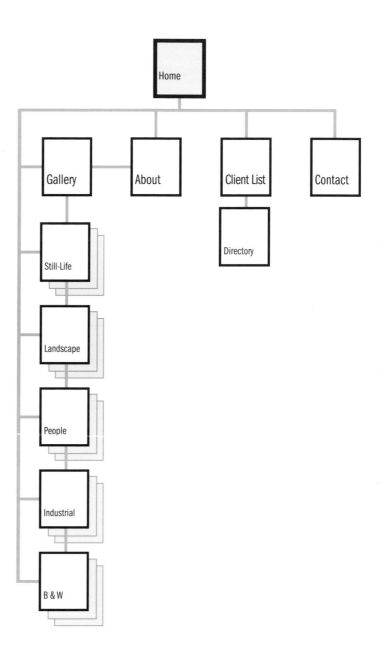

SUBPAGE

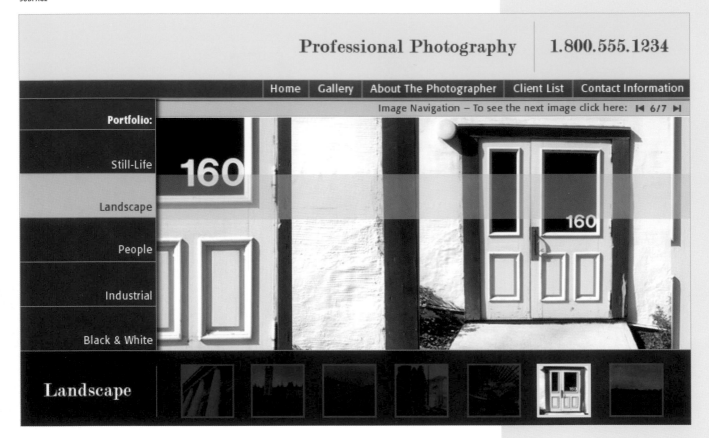

SUBPAGE

POP-UP PAGE

Directory

Lorem ipsum dolor sit amet, consetetur sadipscing elitr, sed diam nonumy eirmod tempor invidunt ut labore et dolore magna aliquyam erat, sed diam voluptua. At vero eos et accusam et justo duo dolores et ea rebum.

 Stet clita kasd gubergren, no sea takimata sanctus est Lorem ipsum dolor sit amet. Lorem ipsum dolor sit amet, consetetur sadipscing elitr, sed diam nonumy eirmod tempor invidunt ut labore et dolore magna aliquyam erat, sed diam voluptua. At vero eos et accusam et justo duo dolores et ea rebum. Stet clita kasd gubergren, no sea takimata sanctus est Lorem ipsum dolor sit amet.

Lorem ipsum dolor sit amet, consetetur sadipscing elitr, sed diam nonumy eirmod tempor invidunt ut labore et dolore magna aliquyam erat, sed diam voluptua. At vero eos et accusam et justo duo dolores et ea rebum. Stet clita kasd gubergren, no sea takimata sanctus est Lorem ipsum dolor sit amet.

Close Window

SUBPAGE

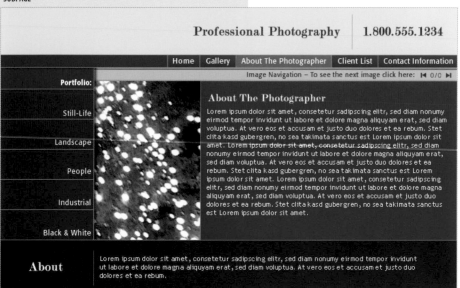

Professional Photography | 1.800.555.1234

Home | Gallery | About The Photographer | Client List | Contact Information

Image Navigation – To see the next image click here: ◄ 0/0 ►

Portfolio:

Still-Life

Landscape

People

Industrial

Black & White

About The Photographer

Lorem ipsum dolor sit amet, consetetur sadipscing elitr, sed diam nonumy eirmod tempor invidunt ut labore et dolore magna aliquyam erat, sed diam voluptua. At vero eos et accusam et justo duo dolores et ea rebum. Stet clita kasd gubergren, no sea takimata sanctus est Lorem ipsum dolor sit amet. Lorem ipsum dolor sit amet, consetetur sadipscing elitr, sed diam nonumy eirmod tempor invidunt ut labore et dolore magna aliquyam erat, sed diam voluptua. At vero eos et accusam et justo duo dolores et ea rebum. Stet clita kasd gubergren, no sea takimata sanctus est Lorem ipsum dolor sit amet. Lorem ipsum dolor sit amet, consetetur sadipscing elitr, sed diam nonumy eirmod tempor invidunt ut labore et dolore magna aliquyam erat, sed diam voluptua. At vero eos et accusam et justo duo dolores et ea rebum. Stet clita kasd gubergren, no sea takimata sanctus est Lorem ipsum dolor sit amet.

About

Lorem ipsum dolor sit amet, consetetur sadipscing elitr, sed diam nonumy eirmod tempor invidunt ut labore et dolore magna aliquyam erat, sed diam voluptua. At vero eos et accusam et justo duo dolores et ea rebum.

Using the design grid, as in this site, ensures clarity of organization and indicates professionalism. The two grids shown here help give the site a focused, well-ordered feel.

When a picture is scanned into a computer, its colors tend to fade.

Thus, it is essential to color-correct scanned images. Clear, brilliant visuals are vitally important to any photo album site.

This image was cropped and the most appealing portion selected for use. It is always a good idea to crop and otherwise alter images to achieve the optimal effect.

Cascading Style Sheet (CSS)

```
BODY {
scrollbar-face-color: #9E0039;
scrollbar-highlight-color: #7E002E;
scrollbar-3dlight-color: #7E002E;
scrollbar-darkshadow-color: #C80149;
scrollbar-shadow-color: #C80149;
scrollbar-arrow-color: #CF809C;
scrollbar-track-color: #D990AA;
}

TD {font-family: Trebuchet MS, Verdana, Arial,
sans-serif; font-size: 11px; color: #FFFFFF; }

P {font-family: Trebuchet MS, Verdana, Arial,
sans-serif; font-size: 11px; color: #FFFFFF; }

A:link {color: #FFFFFF; }
A:visited {color: #FFFFFF; }
A:hover {color: #FFFFFF; text-decoration: none; }
A:active {color: #FFFFFF; }

.Title {font-size: 16px; font-weight: bold; }
.SubTitle {font-size: 14px; }
.Footer {font-size: 9px; }
```

STYLE 21
Random Images Site
Using Variety to Add Spice

It is a good idea, where possible, to use available technology to add character to your Web site. For example, you can create a random images site, where users see different images each time they visit. This technique is effective in that it keeps the Web site interesting after multiple visits, encouraging users to return for another look.

#99A1A3

#00A9D9

HOME PAGE

Home / Bio / Photo Album / Press Kit / Contact

Sandra Scott

.Home

Lorem ipsum dolor sit amet, consetetur sadipscing elitr, sed diam nonumy eirmod tempor invidunt ut labore et dolore magna aliquyam erat, sed diam voluptua. At vero eos et accusam et justo duo dolores et ea rebum. Stet clita kasd gubergren, no sea takimata sanctus est Lorem ipsum dolor sit amet. Lorem ipsum dolor sit amet, consetetur sadipscing elitr, sed diam nonumy eirmod tempor invidunt ut labore et dolore magna aliquyam erat, sed diam voluptua. At vero eos et accusam et justo duo dolores et ea rebum. Stet clita kasd gubergren, no sea takimata sanctus est Lorem ipsum dolor sit amet. Lorem ipsum dolor sit amet, consetetur sadipscing elitr, sed diam nonumy eirmod tempor invidunt ut labore et dolore magna aliquyam erat, sed diam voluptua. At vero eos et accusam et justo duo dolores et ea rebum. Stet clita kasd gubergren, no sea takimata sanctus est Lorem ipsum dolor sit amet.

HOME PAGE

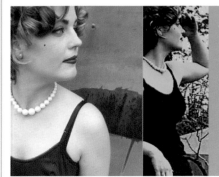

SUBPAGE

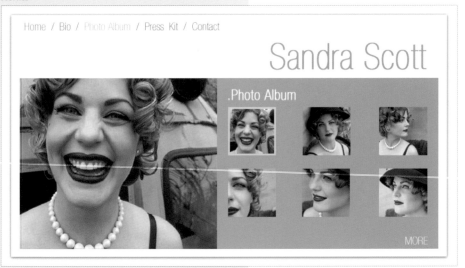

POP-UP PAGE

Though usually engaging, a random images site might not be appropriate in all circumstances. A site where different images appear each time users enter might be ideal to promote an actor or a single product, but if a company wants to promote an entire product line and different products appear with each visit, the site will be ineffective. Users will see only select products on any single visit to the site, negating the company's attempt to promote the entire line.

A random images effect is a good way to keep your site fresh and to give users a reason to come back time and again. Just be sure that such a site is appropriate to your industry before implementing this type of design.

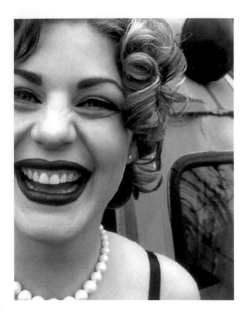

Six different images can appear on the home page. The images are pooled in an image folder and pulled up at random when the site loads, refreshes, or is revisited.

Looking at the layout of the bare site—without elements—we see the structure resembles that of a business card. This gives the site a familiar, personal feel. Because the design exists within an enclosed border, the entire site is centered within the browser.

Cascading Style Sheet (CSS)

```
TD {font-family: Verdana, Arial, Helvetica,
sans-serif; font-size: 11px; color: #FFFFFF; }

P {font-family: Verdana, Arial, Helvetica,
sans-serif; font-size: 11px; color: #FFFFFF; }

A:link {color: #FFFFFF; }
A:visited {color: #FFFFFF; }
A:hover {color: #B2EAFA; }
A:active {color: #B2EAFA; }

.Title {font-size: 16px; font-weight: bold; }
.SubTitle {font-size: 14px; }
.Footer {font-size: 9px; }
```

STYLE 22
E-Commerce Site
Selling Online

Web sites from which users can buy online are becoming ever more popular. E-commerce sites allow customers not only to view your product and learn more about it but also to complete the transaction by arranging to purchase. In recent years, e-sales have become increasingly prevalent in a variety of industries.

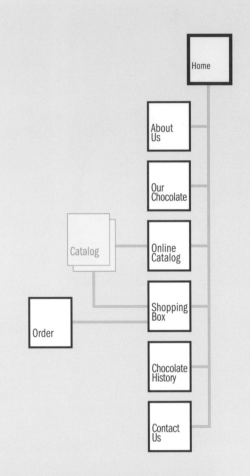

HOME PAGE

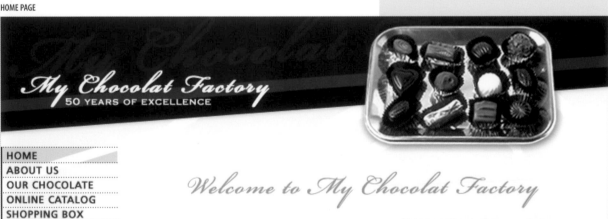

HOME
ABOUT US
OUR CHOCOLATE
ONLINE CATALOG
SHOPPING BOX
CHOCOLATE HISTORY
CONTACT US

Welcome to My Chocolat Factory

Lorem ipsum dolor sit amet, consetetur sadipscing elitr, sed diam nonumy eirmod tempor invidunt ut labore et dolore magna aliquyam erat, sed diam voluptua. At vero eos et accusam et justo duo dolores et ea rebum. Stet clita kasd gubergren, no sea takimata sanctus est Lorem ipsum dolor sit amet. Lorem ipsum dolor sit amet, consetetur sadipscing elitr, sed diam nonumy eirmod tempor invidunt ut labore et dolore magna aliquyam erat, sed diam voluptua. **At vero eos et accusam et justo duo dolores et ea rebum.**

Duis autem vel eum iriure dolor in hendrerit in vulputate velit esse molestie consequat, vel illum dolore eu feugiat nulla facilisis at vero eros et **accumsan et iusto odio dignissim qui blandit praesent luptatum zzril delenit augue duis dolore te feugait nulla facilisi.** Lorem ipsum dolor sit amet, consectetuer adipiscing elit, sed diam nonummy nibh euismod tincidunt ut laoreet dolore magna aliquam erat volutpat.

#FBF8E4
#EFEBCE
#AD2818
#CE3C00
#942008

When designing an e-commerce site, it is important to make clear to users that you are selling your product online and that it is a product they want to buy. Make sure the product is clearly displayed, with a variety of images that give users a good sense of how it looks or what it does. Additional features, such as image zoom options and information bubbles, are also advantageous and help put users at ease in deciding to purchase online.

It is crucial in designing an e-commerce site to make sure users feel your site is legitimate and trustworthy. A sober, earnest atmosphere lets users know you are somebody they can safely do business with in an often confusing online world. Be honest with your users so they understand where you are coming from and what you are trying to do. Help people feel you employ standard selling practices so they are comfortable engaging in a business transaction with you.

Trust is of the utmost importance in e-commerce sales, so make sure your site looks as professional as possible, with regular maintenance and periodic updates. People are more likely to buy if they sense your company is stable and serious. It is not necessary, however, for your site to be highly involved, like that of a major corporation. Even small businesses can build users' trust so as to be able to conduct e-business.

E-commerce is an excellent method of boosting revenues and of showing that your company is ready to do business in the twenty-first century. But human support for online sales is critical. Have your company's contact information prominently displayed on all pages and arrange for a live person to answer calls. Ensure your customer service is reliable and friendly—again, so as to build trust and encourage users to buy from your site.

SUBPAGE

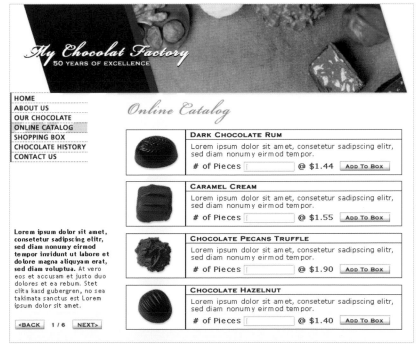

SUBPAGE

POP-UP PAGE

Each page uses a different letter as a part of its background—that letter being the first in the title of the page. This gives the site a rich, full effect. Also, the background is designed to be larger than the pages so it can extend on larger monitors without revealing that it tiles repetitively.

Banner ads promoting the product are displayed prominently. As this is an e-commerce site, it is a good idea to exhibit such ads to help market the product.

Cascading Style Sheet (CSS)

```
BODY {
scrollbar-face-color: #AD2818;
scrollbar-highlight-color: #A93E28;
scrollbar-3dlight-color: #BF4E37;
scrollbar-darkshadow-color: #942008;
scrollbar-shadow-color: #A93E28;
scrollbar-arrow-color: #DFA837;
scrollbar-track-color: #FBF8E4;
}

TD {font-family: Trebuchet MS, Verdana, Arial,
sans-serif; font-size: 12px; color: #942008; }

P {font-family: Trebuchet MS, Verdana, Arial,
sans-serif; font-size: 12px; color: #942008; }

A:link {color: #DA9206; }
A:visited {color: #DA9206; }
A:hover {color: #942008; text-decoration: none; }
A:active {color: #942008; }

.Title {font-size: 16px; font-weight: bold; color: #DA9206; }
.SubTitle {font-size: 14px; color: #CF931D; }
.Footer {font-size: 9px; }
```

STYLE 23
Web Typography
Matching Style to Content

Good typography involves the use of text and typeface to create a visual atmosphere both appealing to the eye and appropriate to the content. Though it is important for your text to be well written and easy to read, it is also crucial that it look right on the page. Elements of typography—size, spacing, color, and format—if used with a good sense of design, will give your page an aesthetically pleasing look.

As readers scan the pages of your site, good typography and design help them understand how the elements on each page relate to one another. For example, you can incorporate bold text to stress key aspects of a page. Users are drawn to the bold text as they scan the text on your site.

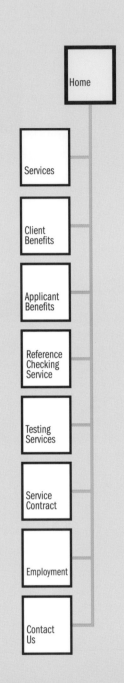

#067ABA
#FF9933
#663300

Emphasizing key points focuses users on what you want them to see and know about your company. Stressing important areas of text allows users to jump down and see what they will be reading or perhaps skip to an area they are more interested in.

Choosing the right typeface for logos, titles, and so on is a vital aspect of good typography. It is always important that the typeface you use match the character of your site's design. For example, a traditional corporate site would not want to use an elaborate, decorative typeface to represent its interests. A conservative sans-serif typeface is more appropriate, matching the overall feel of the site. It is important to select typefaces carefully to ensure that they characterize the essence of your company.

For the purposes of text used for content on your site, it is generally best to employ a sans-serif typeface (for example, Arial and Verdana) to ensure the words are readable. As the characters on a Web site are made up of pixels, a straight-lined sans-serif typeface is more legible than a more elaborate serif typeface (for example, Times New Roman and Georgia) that has curves and accents. In order to keep your mood consistent, it is best not to use more than two or three typefaces per page. If more than one typeface is used, all should be very different in appearance. Similar typefaces on the same page just make the user think a mistake has been made, which may be unsettling for them and will not reflect well on you.

Typography is an aspect of design that will go unnoticed if executed well but that will be awkward and unsettling if not. Take time to ensure your typography matches the style you are trying to convey. Be sure readers can focus visually on what you want them to see.

A four-step process is used to create the image at the top of each page. First, a color image is selected.

Next, the image is transformed to duotone color.

A shape drawn from the logo is then placed on top of the image.

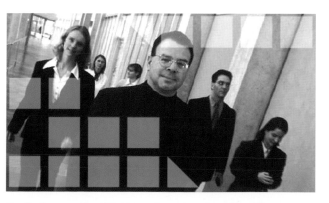

Finally, the opacity of the logo shape is reduced by 40 percent.

HOME PAGE

■ **Face to face communication** - The Interview remains a key element in your recruiting process, but is often difficult to achieve at a **realistic cost.** Many applicants live great distances from your site and paying for them to visit the site can be very expensive.

HOME PAGE
INTERVIEW SERVICES
CLIENT BENEFITS
APPLICANT BENEFITS
REFERENCE CHECKING SERVICE
TESTING SERVICES
ARRANGE SERVICE CONTRACT
EMPLOYMENT OPPORTUNITIES
CONTACT US

Back To Top

WELCOME TO INTERVIEWPROS

Lorem ipsum dolor sit amet, consetetur sadipscing elitr, sed diam nonumy eirmod tempor invidunt ut labore et dolore magna aliquyam erat, sed diam voluptua. At vero eos et accusam et justo duo dolores et ea rebum. Stet clita kasd gubergren, no sea takimata sanctus est Lorem ipsum dolor sit amet. Lorem ipsum dolor sit amet, consetetur sadipscing elitr, sed diam nonumy eirmod tempor invidunt ut labore et dolore magna aliquyam erat, sed diam voluptua. At vero eos et accusam et justo duo dolores et ea rebum. Stet clita kasd gubergren, no sea takimata sanctus est Lorem ipsum dolor sit amet. Lorem ipsum dolor sit amet, consetetur sadipscing elitr, sed diam nonumy eirmod tempor invidunt ut labore et dolore magna aliquyam erat, sed diam voluptua. At vero eos et accusam et justo duo dolores et ea rebum. Stet clita kasd gubergren, no sea takimata sanctus est Lorem ipsum dolor sit amet.

Duis autem vel eum iriure dolor in hendrerit in vulputate velit esse molestie consequat, vel illum dolore eu feugiat nulla facilisis at vero eros et accumsan et iusto odio dignissim qui blandit praesent luptatum zzril delenit augue duis dolore te feugait nulla facilisi. Lorem ipsum dolor sit amet, consectetuer adipiscing elit, sed diam nonummy nibh euismod tincidunt ut laoreet dolore magna aliquam erat volutpat.

Ut wisi enim ad minim veniam, quis nostrud exerci tation ullamcorper suscipit lobortis nisl ut aliquip ex ea commodo consequat. Duis autem vel eum iriure dolor in hendrerit in vulputate velit esse molestie consequat, vel illum dolore eu feugiat **nulla facilisis at vero eros et accumsan et iusto** odio dignissim qui blandit praesent luptatum zzril delenit augue duis dolore te feugait nulla facilisi.

Nam liber tempor cum soluta nobis eleifend option congue nihil imperdiet doming id quod mazim placerat facer possim assum. Lorem ipsum dolor sit amet, consectetuer adipiscing elit, sed diam nonummy nibh euismod tincidunt ut laoreet dolore magna aliquam erat volutpat. Ut wisi enim ad minim veniam, quis nostrud exerci tation ullamcorper suscipit lobortis nisl ut aliquip ex ea commodo consequat.

Drawing a shape from the logo on each image is a method of branding that helps users remember the logo and the company. This content-rich site requires users to scroll to see all of the content on each page.

SUBPAGE

■ **Internet recruiting has caused a massive shift in hiring practices.** It has brought with it a huge increase in the number of applicants, along with the major challenge of sorting out who should be among the **finalists for a position.**

HOME PAGE
INTERVIEW SERVICES
CLIENT BENEFITS
APPLICANT BENEFITS
REFERENCE CHECKING SERVICE
TESTING SERVICES
ARRANGE SERVICE CONTRACT
EMPLOYMENT OPPORTUNITIES
CONTACT US

Back To Top

INTERVIEWSERVICES

Lorem ipsum dolor sit amet, consetetur sadipscing elitr, sed diam nonumy eirmod tempor invidunt ut labore et dolore magna aliquyam erat, sed diam voluptua. At vero eos et accusam et justo duo dolores et ea rebum. Stet clita kasd gubergren, no sea takimata sanctus est Lorem ipsum dolor sit amet. Lorem ipsum dolor sit amet, consetetur sadipscing elitr, sed diam nonumy eirmod tempor invidunt ut labore et dolore magna aliquyam erat, sed diam voluptua. At vero eos et accusam et justo duo dolores et ea rebum. Stet clita kasd gubergren, no sea takimata sanctus est Lorem ipsum dolor sit amet. Lorem ipsum dolor sit amet, **consetetur sadipscing elitr, sed diam nonumy eirmod tempor invidunt ut labore et dolore magna aliquyam erat,** sed diam voluptua. At vero eos et accusam et justo duo dolores et ea rebum. Stet clita kasd gubergren, no sea takimata sanctus est Lorem ipsum dolor sit amet.

Duis autem vel eum iriure dolor in hendrerit in vulputate velit esse molestie consequat, vel illum dolore eu feugiat nulla facilisis at vero eros et accumsan et iusto odio dignissim qui blandit praesent luptatum zzril delenit augue duis dolore te feugait nulla facilisi. Lorem ipsum dolor sit amet, consectetuer adipiscing elit, sed diam nonummy nibh euismod tincidunt ut laoreet dolore magna aliquam erat volutpat.

Ut wisi enim ad minim veniam, quis nostrud exerci tation ullamcorper suscipit lobortis nisl ut aliquip ex ea commodo consequat. Duis autem vel eum iriure dolor in hendrerit in vulputate velit esse molestie consequat, vel illum dolore eu feugiat nulla facilisis at vero eros et accumsan et iusto odio dignissim qui blandit praesent luptatum zzril delenit augue duis dolore te feugait nulla facilisi.

Nam liber tempor cum soluta nobis eleifend option congue nihil imperdiet doming id quod mazim placerat facer possim assum. Lorem ipsum dolor sit amet, consectetuer adipiscing elit, sed diam nonummy nibh euismod tincidunt ut laoreet dolore magna aliquam erat volutpat. Ut wisi enim ad minim veniam, **quis nostrud exerci tation ullamcorper suscipit lobortis nisl ut aliquip ex ea commodo consequat.**

POP-UP PAGE

CLOSE WINDOW

PRIVACYPOLICIES

Lorem ipsum dolor sit amet, consetetur sadipscing elitr, sed diam nonumy eirmod tempor invidunt ut labore et dolore magna aliquyam erat, sed diam voluptua. At vero eos et accusam et justo duo dolores et ea rebum. Stet clita kasd gubergren, no sea takimata sanctus est Lorem ipsum dolor sit Lorem ipsum dolor sit amet, consetetur sadipscing elitr, sed diam nonumy eirmod tempor invidunt ut labore et dolore magna aliquyam erat, sed diam voluptua. At vero eos et accusam et justo duo dolores et ea rebum. Stet clita kasd gubergren, no sea takimata sanctus est Lorem ipsum dolor sit amet. Lorem ipsum dolor sit amet, consetetur sadipscing elitr, sed diam nonumy eirmod tempor invidunt ut labore et dolore magna aliquyam erat, sed diam voluptua. At vero eos et accusam et justo duo dolores et ea rebum. Stet clita kasd gubergren, no sea takimata sanctus est Lorem ipsum dolor sit amet.

Back To Top

At the bottom of each page is a Back to Top button that returns users to a position from which they can continue navigation; this convenient feature conveys a sense of continuity.

Cascading Style Sheet (CSS)

```
BODY {
scrollbar-face-color: #067ABA;
scrollbar-highlight-color: #1990D1;
scrollbar-3dlight-color: #0E82C2;
scrollbar-darkshadow-color: #02649A;
scrollbar-shadow-color: #0470AC;
scrollbar-arrow-color: #C0E3F6;
scrollbar-track-color: #C0E3F6;
}

TD {font-family: Verdana, Arial, Helvetica,
sans-serif; font-size: 12px; color: #663300; }

P {font-family: Verdana, Arial, Helvetica,
sans-serif; font-size: 12px; color: #663300; }

A:link {color: #FF7518; }
A:visited {color: #FF7518; }
A:hover {color: #663300; text-decoration: none; }
A:active {color: #663300; }

.Title {font-size: 16px; font-weight: bold; }
.SubTitle {font-size: 14px; }
.Footer {font-size: 9px; }
```

Web site designed for:

InterviewPros

www.interviewpros.com

STYLE 24

Managing Information

Organizing Your Content Effectively

When faced with presenting large amounts of information, you are smart to worry about how to do so competently. What information should you present? How should you organize it? What should be given priority? Mass amounts of content can often feel overwhelming.

Fortunately, a Web site is the ideal vehicle for presenting large quantities of information. One of the keys to good content management is remembering that not everything need appear on your home page. Though obviously all of your information couldn't possibly be presented on your home page, you may be tempted to display more information than is necessary and thus clutter this initial page. Remember, your home page is the center of your site. Its job is to divide information into subsections and help people get to what they want to see.

Another temptation is to cram as much information as possible onto each page. Unfortunately, if users feel overwhelmed by massive amounts of content, they may be inclined to leave. Use extra pages and leave lots of open space on each page. Open space puts users at ease and increases the likelihood they will read the words you've written. Remember, users tend to scan pages rather than read every word. If your page features large blocks of densely packed text, users may miss the piece of information they were trying to find.

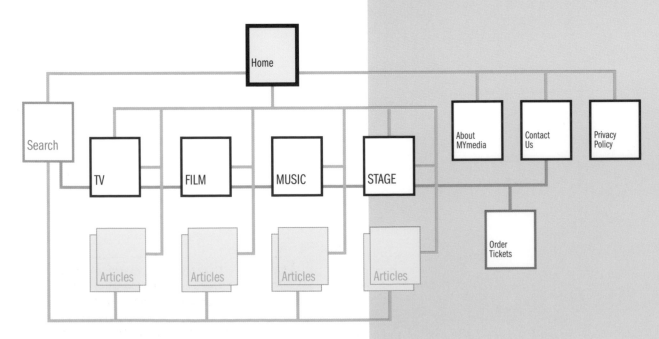

It is a misconception that you should create pages in such a way that they do not require a scroll bar. Scrolling is a standard part of using computers and the Internet—users will not be put off if they have to scroll. It is better to have a page that is easily scanned and has a scroll bar than a page with no scroll bar and densely packed text that is difficult to read.

Other steps can be taken to make content-heavy sites easier to work with. Maintaining the same page structure where information changes on a regular basis (for example, always putting theater articles at the top of the page) helps users know where they should look to find what they want. Also, associating topic areas with specific colors can help with the usability of your site—people are visual thinkers and will remember what each color represents.

#C2CAD3

#92C1F3

#C2ED79

#83D0F0

#A1AEFC

#F9D8A5

HOME PAGE

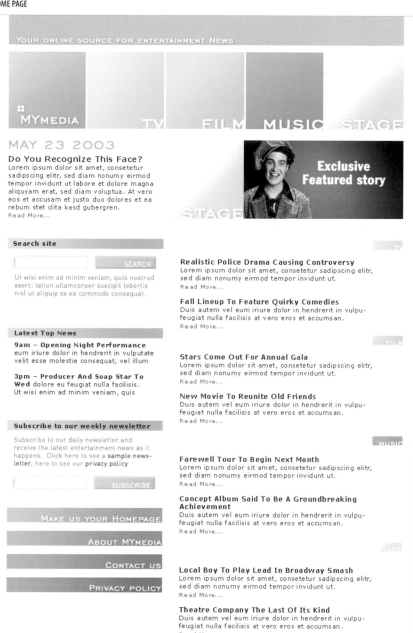

TIP: DESIGNING FOR THE VISUALLY IMPAIRED

When designing a site with a large amount of content, you may wish (depending on your target audience) to accommodate users who are visually challenged. A technique as simple as using ALT tags with meaningful explanations on all images can greatly assist users who use voice browsers to navigate your site. For example, instead of an ALT tag that says only Click Here for a link, it could say Link: News and Events so as to make the option more explicit.

HOME PAGE

YOUR ONLINE SOURCE FOR ENTERTAINMENT NEWS

MYMEDIA TV FILM MUSIC STAGE

MAY 23 2003

Do You Recognize This Face?

Lorem ipsum dolor sit amet, consetetur sadipscing elitr, sed diam nonumy eirmod tempor invidunt ut labore et dolore magna aliquyam erat, sed diam voluptua. At vero eos et accusam et justo duo dolores et ea rebum stet clita kasd gubergren.
Read More...

STAGE

Exclusive Featured story

Search site

[] SEARCH

Ut wisi enim ad minim veniam, quis nostrud exerci tation ullamcorper suscipit lobortis nisl ut aliquip ex ea commodo consequat.

Latest Top News

9am – Opening Night Performance eum iriure dolor in hendrerit in vulputate velit esse molestie consequat, vel illum

3pm – Producer And Soap Star To Wed dolore eu feugiat nulla facilisis. Ut wisi enim ad minim veniam, quis

Subscribe to our weekly newsletter

Subscribe to our daily newsletter and receive the latest entertainment news as it happens. Click here to see a **sample news-letter**, here to see our **privacy policy**

[] SUBSCRIBE

MAKE US YOUR HOMEPAGE

ABOUT MYMEDIA

CONTACT US

PRIVACY POLICY

TV

Realistic Police Drama Causing Controversy

Lorem ipsum dolor sit amet, consetetur sadipscing elitr, sed diam nonumy eirmod tempor invidunt ut.
Read More...

Fall Lineup To Feature Quirky Comedies

Duis autem vel eum iriure dolor in hendrerit in vulpu-feugiat nulla facilisis at vero eros et accumsan.
Read More...

FILM

Stars Come Out For Annual Gala

Lorem ipsum dolor sit amet, consetetur sadipscing elitr, sed diam nonumy eirmod tempor invidunt ut.
Read More...

New Movie To Reunite Old Friends

Duis autem vel eum iriure dolor in hendrerit in vulpu-feugiat nulla facilisis at vero eros et accumsan.
Read More...

MUSIC

Farewell Tour To Begin Next Month

Lorem ipsum dolor sit amet, consetetur sadipscing elitr, sed diam nonumy eirmod tempor invidunt ut.
Read More...

Concept Album Said To Be A Groundbreaking Achievement

Duis autem vel eum iriure dolor in hendrerit in vulpu-feugiat nulla facilisis at vero eros et accumsan.
Read More...

STAGE

Local Boy To Play Lead In Broadway Smash

Lorem ipsum dolor sit amet, consetetur sadipscing elitr, sed diam nonumy eirmod tempor invidunt ut.
Read More...

Theatre Company The Last Of Its Kind

Duis autem vel eum iriure dolor in hendrerit in vulpu-feugiat nulla facilisis at vero eros et accumsan.
Read More...

SUBPAGE

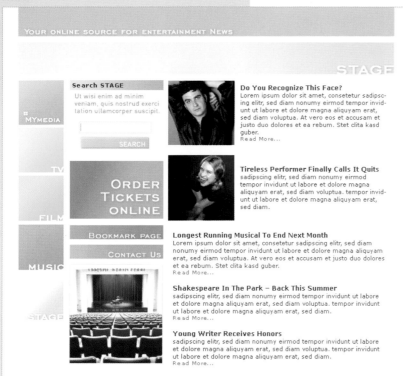

YOUR ONLINE SOURCE FOR ENTERTAINMENT NEWS

STAGE

MYMEDIA

TV

FILM

MUSIC

STAGE

Search STAGE
Ut wisi enim ad minim veniam, quis nostrud exerci tation ullamcorper suscipit.

SEARCH

ORDER TICKETS ONLINE

BOOKMARK PAGE

CONTACT US

Do You Recognize This Face?
Lorem ipsum dolor sit amet, consetetur sadipscing elitr, sed diam nonumy eirmod tempor invidunt ut labore et dolore magna aliquyam erat, sed diam voluptua. At vero eos et accusam et justo duo dolores et ea rebum. Stet clita kasd guber.
Read More...

Tireless Performer Finally Calls It Quits
sadipscing elitr, sed diam nonumy eirmod tempor invidunt ut labore et dolore magna aliquyam erat, sed diam voluptua. tempor invidunt ut labore et dolore magna aliquyam erat, sed diam.

Longest Running Musical To End Next Month
Lorem ipsum dolor sit amet, consetetur sadipscing elitr, sed diam nonumy eirmod tempor invidunt ut labore et dolore magna aliquyam erat, sed diam voluptua. At vero eos et accusam et justo duo dolores et ea rebum. Stet clita kasd guber.
Read More...

Shakespeare In The Park – Back This Summer
sadipscing elitr, sed diam nonumy eirmod tempor invidunt ut labore et dolore magna aliquyam erat, sed diam voluptua. tempor invidunt ut labore et dolore magna aliquyam erat, sed diam.
Read More...

Young Writer Receives Honors
sadipscing elitr, sed diam nonumy eirmod tempor invidunt ut labore et dolore magna aliquyam erat, sed diam voluptua. tempor invidunt ut labore et dolore magna aliquyam erat, sed diam.
Read More...

SUBPAGE

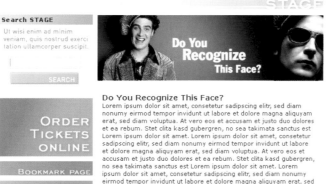

YOUR ONLINE SOURCE FOR ENTERTAINMENT NEWS

STAGE

MYMEDIA

TV

FILM

MUSIC

STAGE

Search STAGE
Ut wisi enim ad minim veniam, quis nostrud exerci tation ullamcorper suscipit.

SEARCH

ORDER TICKETS ONLINE

BOOKMARK PAGE

PRINT PAGE

Do You Recognize This Face?

Do You Recognize This Face?
Lorem ipsum dolor sit amet, consetetur sadipscing elitr, sed diam nonumy eirmod tempor invidunt ut labore et dolore magna aliquyam erat, sed diam voluptua. At vero eos et accusam et justo duo dolores et ea rebum. Stet clita kasd gubergren, no sea takimata sanctus est Lorem ipsum dolor sit amet. Lorem ipsum dolor sit amet, consetetur sadipscing elitr, sed diam nonumy eirmod tempor invidunt ut labore et dolore magna aliquyam erat, sed diam voluptua. At vero eos et accusam et justo duo dolores et ea rebum. Stet clita kasd gubergren, no sea takimata sanctus est Lorem ipsum dolor sit amet. Lorem ipsum dolor sit amet, consetetur sadipscing elitr, sed diam nonumy eirmod tempor invidunt ut labore et dolore magna aliquyam erat, sed diam voluptua. At vero eos et accusam et justo duo dolores et ea rebum. Stet clita kasd gubergren, no sea takimata sanctus est Lorem ipsum dolor sit amet.

Duis autem vel eum iriure dolor in hendrerit in vulputate velit esse molestie consequat, vel illum dolore eu feugiat nulla facilisis at vero eros et accumsan et iusto odio dignissim qui blandit praesent luptatum zzril delenit augue duis dolore te feugait nulla facilisi. Lorem ipsum dolor sit amet, consectetuer adipiscing elit, sed diam nonummy nibh euismod tincidunt ut laoreet dolore magna aliquam erat volutpat.

Ut wisi enim ad minim veniam, quis nostrud exerci tation ullamcorper suscipit lobortis nisl ut aliquip ex ea commodo consequat. Duis autem vel eum iriure dolor in hendrerit in vulputate velit esse molestie consequat, vel illum dolore eu feugiat nulla facilisis at vero eros et accumsan et iusto odio dignissim qui blandit praesent luptatum zzril delenit augue duis dolore te feugait nulla facilisi.

POP-UP PAGE

MYMEDIA

PRIVACY POLICIES

Lorem ipsum dolor sit amet, consetetur sadipscing elitr, sed diam nonumy eirmod tempor invidunt ut labore et dolore magna aliquyam erat, sed diam voluptua. At vero eos et accusam et justo duo dolores et ea rebum. Stet clita kasd gubergren, no sea takimata sanctus est Lorem ipsum dolor sit Lorem ipsum dolor sit amet, consetetur sadipscing elitr, sed diam nonumy eirmod tempor invidunt ut labore et dolore magna aliquyam erat, sed diam voluptua. At vero eos et accusam et justo duo dolores et ea rebum. Stet clita kasd gubergren, no sea takimata sanctus est Lorem ipsum dolor sit amet. Lorem ipsum dolor sit amet, consetetur sadipscing elitr, sed diam nonumy eirmod tempor invidunt ut labore et dolore magna aliquyam erat, sed diam voluptua. At vero eos et accusam et justo duo dolores et ea rebum. Stet clita kasd gubergren, no sea takimata sanctus est Lorem ipsum dolor sit amet.

CLOSE WINDOW

Your online source for entertainment News

This site uses the top of the page to tell users what the site is about. This is also a good place to display banner ads.

As users roll over the main menu items, images appear that represent each topic area. Clicking on one of the topics takes you to articles on that subject. Some featured articles can be accessed directly from the home page.

A search box allows users to find subjects they are looking for. Having a search box is especially appropriate where a large amount of information is being presented or where information is constantly changing.

Ut wisi enim ad minim veniam, quis nostrud exerci tation ullamcorper suscipit lobortis nisl ut aliquip ex ea commodo consequat.

Offering a periodic newsletter can be a good way to get people back to your site. Be sure your privacy policy is clearly stated and that users know to what they are subscribing.

Subscribe to our daily newsletter and receive the latest entertainment news as it happens. Click here to see a **sample news-letter**, here to see our **privacy policy**.

Cascading Style Sheet (CSS)

```
BODY {
scrollbar-face-color: #A3CBF7;
scrollbar-highlight-color: #BCDAFB;
scrollbar-3dlight-color: #AED1F9;
scrollbar-darkshadow-color: #90BFF3;
scrollbar-shadow-color: #94C1F4;
scrollbar-arrow-color: #C6DDF7;
scrollbar-track-color: #B9D8FA;
}

TD {font-family: Verdana, Arial, Helvetica,
sans-serif; font-size: 11px; color: #135299; }

P {font-family: Verdana, Arial, Helvetica,
sans-serif; font-size: 11px; color: #135299; }

A:link {color: #025BC0; }
A:visited {color: #025BC0; text-decoration: none; }
A:hover {color: #348FF5; }
A:active {color: #348FF5; }

.Title {font-size: 15px; font-weight: bold; }
.SubTitle {font-size: 12px; font-weight: bold; }
.ReadMore {font-size: 10px; color: #3879C2; }
.Footer {font-size: 9px; }
```

STYLE 25
Less Is More
Using White Space

White space, also known as *negative space*, is the open space between the design elements on your site. This empty area amid text, images, logos, and so on helps guide users' eyes from place to place, telling them where to focus their attention. Though white space is often overlooked, it is an important aspect of effective Web design.

HOME PAGE

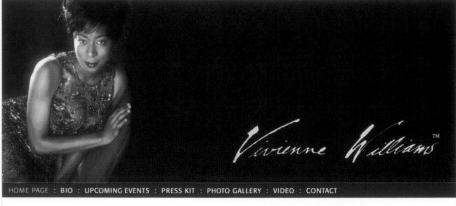

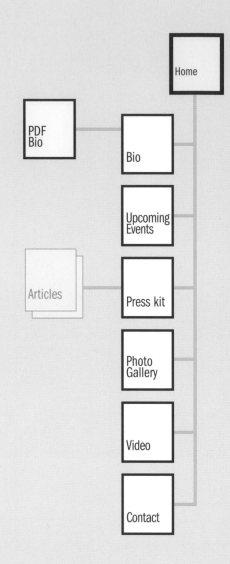

#FFF7FF
#DECBDE
#C6004A
#422842

White space needn't always be white—its color will differ depending on the background used for the particular page. Essentially, it is a blank area where the eye can rest and take a brief break from the material being viewed. Reading Web pages can be difficult task—almost mesmerizing at times, and often quite exhausting. Appropriate use of white space can make navigating through a site a more enjoyable experience.

Having large amounts of white space on a page will not necessarily make your site look sparse or unprofessional; in fact, a page with fewer elements can often have greater impact than a cluttered, densely packed page. It is important, however, when considering white space, to ensure a balance between design elements. Users' focus should be directed to areas of your choosing. Make certain each page has symmetry so that no one component receives unintended stress.

The effect of white space is subtle but nonetheless crucial to the usability of your site. Appropriate use of white space gives pages a flow and elegance frequently lacking in pages with large amounts of text and images. Though you may be tempted to say and show as much as you can on a Web page, it is always important to think about spacing and to remember that, sometimes, less is more.

The animated logo for this site is the artist's signature, which looks as if it is being written as new visitors watch. This holds their attention for a few seconds, subtly keeping their focus on the name of the artist.

DESIGN TEMPLATES: LESS IS MORE

SUBPAGE

HOME PAGE : BIO : UPCOMING EVENTS : PRESS KIT : PHOTO GALLERY : VIDEO : CONTACT

Download printable version (PDF 276kb)
Requires Adobe Acrobat

Bookmark This Page

VIVIENNE WILLIAMS BIO

Lorem ipsum dolor sit amet, consetetur sadipscing elitr, sed diam nonumy eirmod tempor invidunt ut labore et dolore magna aliquyam erat, sed diam voluptua. At vero eos et accusam et justo duo dolores et ea rebum. Stet clita kasd gubergren, no sea takimata sanctus est Lorem ipsum dolor sit amet. Lorem ipsum dolor sit amet, consetetur sadipscing elitr, sed diam nonumy eirmod tempor invidunt ut labore et dolore magna aliquyam erat, sed diam voluptua. At vero eos et accusam et justo duo dolores et ea rebum. Stet clita kasd gubergren, no sea takimata sanctus est Lorem ipsum dolor sit amet. Lorem ipsum dolor sit amet, consetetur sadipscing elitr, sed diam nonumy eirmod tempor invidunt ut labore et dolore magna aliquyam erat, sed diam voluptua. At vero eos et accusam et justo duo dolores et ea rebum. Stet clita kasd gubergren, no sea takimata sanctus est Lorem ipsum dolor sit amet.

Duis autem vel eum iriure dolor in hendrerit in vulputate velit esse molestie consequat, vel illum dolore eu feugiat nulla facilisis at vero eros et accumsan et iusto odio dignissim qui blandit praesent luptatum zzril delenit augue duis dolore te feugait nulla facilisi. Lorem ipsum dolor sit amet, consectetuer adipiscing elit, sed diam nonummy nibh euismod tincidunt ut laoreet dolore magna aliquam erat volutpat.

SUBPAGE

POP-UP PAGE

CLOSE WINDOW

HOME PAGE : BIO : UPCOMING EVENTS : PRESS KIT : PHOTO GALLERY : VIDEO : CONTACT

Bookmark This Page

CONTACT

Lorem ipsum dolor sit amet, consetetur sadipscing elitr, sed diam nonumy eirmod tempor invidunt ut labore.

full name, (first, last):

phone number:

fax:

email address:

address (optional):

city:

prov / state:

postal / zip code:

country:

comments:

Subscribe Vivienne's mailing list: ☐ YES ☐ NO

Submit Reset

CLUB & CONCERT APPEARANCES

2003
Lorem ipsum dolor sit amet, consetetur sadipscing elitr, sed diam nonumy eirmod tempor invidunt ut labore et dolore magna aliquyam erat, sed diam voluptua. At vero eos et accusam et justo duo dolores et ea rebum.

2002
Stet clita kasd gubergren, no sea takimata sanctus est Lorem ipsum dolor sit amet, consetetur sadipscing elitr, sed diam nonumy eirmod tempor invidunt ut labore et dolore magna aliquyam erat, sed diam voluptua.

2001
At vero eos et accusam et justo duo dolores et ea rebum. Stet clita kasd gubergren, no sea takimata sanctus est Lorem ipsum dolor sit amet, consetetur sadipscing elitr, sed diam nonumy eirmod tempor invidunt ut labore et dolore magna aliquyam erat, sed diam voluptua.

2000
At vero eos et accusam et justo duo dolores et ea rebum. Stet clita kasd gubergren, no sea takimata sanctus est Lorem ipsum dolor sit amet.

A color from the right side of the image was chosen as a background color for the rest of the page.

Cascading Style Sheet (CSS)

```
BODY {
scrollbar-face-color: #C6004A;
scrollbar-highlight-color: #E11B65;
scrollbar-3dlight-color: #D50D57;
scrollbar-darkshadow-color: #870233;
scrollbar-shadow-color: #AD0342;
scrollbar-arrow-color: #EFDFEF;
scrollbar-track-color: #DECBDE;
}

TD {font-family: Trebuchet MS, Verdana, Arial,
sans-serif; font-size: 12px; color: #422842; }

P {font-family: Trebuchet MS, Verdana, Arial,
sans-serif; font-size: 12px; color: #422842; }

A:link {color: #C6004A; text-decoration: none; }
A:visited {color: #C6004A; text-decoration: none; }
A:hover {color: #C6004A; text-decoration: underline; }
A:active {color: #C6004A; text-decoration: underline; }

.Title {font-size: 15px; color: #C6004A; font-weight: bold; }
.SubTitle {font-size: 13px; color: #C6004A; font-weight: bold; }
.Footer {font-size: 10px; }
```

Web site designed for:

Vivienne Williams Enterprises

www.viviennewilliams.com

This allows the image to blend gently into the background, making the entire page seem like one continuous image.

Hexadecimal Color Conversion Table

The hexadecimal (hex) value is provided for each color used in the templates. Hex values are the numerical values representative of colors that are commonly used when designing for the Web. The table shows RGB values and their corresponding hex values. For example, an RGB value of 0,169, 217 corresponds to a hex value of 00A9D9.

0 = 00	37 = 25	74 = 4A	111 = 6F	148 = 94	185 = B9	222 = DE
1 = 01	38 = 26	75 = 4B	112 = 70	149 = 95	186 = BA	223 = DF
2 = 02	39 = 27	76 = 4C	113 = 71	150 = 96	187 = BB	224 = E0
3 = 03	40 = 28	77 = 4D	114 = 72	151 = 97	188 = BC	225 = E1
4 = 04	41 = 29	78 = 4E	115 = 73	152 = 98	189 = BD	226 = E2
5 = 05	42 = 2A	79 = 4F	116 = 74	153 = 99	190 = BE	227 = E3
6 = 06	43 = 2B	80 = 50	117 = 75	154 = 9A	191 = BF	228 = E4
7 = 07	44 = 2C	81 = 51	118 = 76	155 = 9B	192 = C0	229 = E5
8 = 08	45 = 2D	82 = 52	119 = 77	156 = 9C	193 = C1	230 = E6
9 = 09	46 = 2E	83 = 53	120 = 78	157 = 9D	194 = C2	231 = E7
10 = 0A	47 = 2F	84 = 54	121 = 79	158 = 9E	195 = C3	232 = E8
11 = 0B	48 = 30	85 = 55	122 = 7A	159 = 9F	196 = C4	233 = E9
12 = 0C	49 = 31	86 = 56	123 = 7B	160 = A0	197 = C5	234 = EA
13 = 0D	50 = 32	87 = 57	124 = 7C	161 = A1	198 = C6	235 = EB
14 = 0E	51 = 33	88 = 58	125 = 7D	162 = A2	199 = C7	236 = EC
15 = 0F	52 = 34	89 = 59	126 = 7E	163 = A3	200 = C8	237 = ED
16 = 10	53 = 35	90 = 5A	127 = 7F	164 = A4	201 = C9	238 = EE
17 = 11	54 = 36	91 = 5B	128 = 80	165 = A5	202 = CA	239 = EF
18 = 12	55 = 37	92 = 5C	129 = 81	166 = A6	203 = CB	240 = F0
19 = 13	56 = 38	93 = 5D	130 = 82	167 = A7	204 = CC	241 = F1
20 = 14	57 = 39	94 = 5E	131 = 83	168 = A8	205 = CD	242 = F2
21 = 15	58 = 3A	95 = 5F	132 = 84	169 = A9	206 = CE	243 = F3
22 = 16	59 = 3B	96 = 60	133 = 85	170 = AA	207 = CF	244 = F4
23 = 17	60 = 3C	97 = 61	134 = 86	171 = AB	208 = D0	245 = F5
24 = 18	61 = 3D	98 = 62	135 = 87	172 = AC	209 = D1	246 = F6
25 = 19	62 = 3E	99 = 63	136 = 88	173 = AD	210 = D2	247 = F7
26 = 1A	63 = 3F	100 = 64	137 = 89	174 = AE	211 = D3	248 = F8
27 = 1B	64 = 40	101 = 65	138 = 8A	175 = AF	212 = D4	249 = F9
28 = 1C	65 = 41	102 = 66	139 = 8B	176 = B0	213 = D5	250 = FA
29 = 1D	66 = 42	103 = 67	140 = 8C	177 = B1	214 = D6	251 = FB
30 = 1E	67 = 43	104 = 68	141 = 8D	178 = B2	215 = D7	252 = FC
31 = 1F	68 = 44	105 = 69	142 = 8E	179 = B3	216 = D8	253 = FD
32 = 20	69 = 45	106 = 6A	143 = 8F	180 = B4	217 = D9	254 = FE
33 = 21	70 = 46	107 = 6B	144 = 90	181 = B5	218 = DA	255 = FF
34 = 22	71 = 47	108 = 6C	145 = 91	182 = B6	219 = DB	
35 = 23	72 = 48	109 = 6D	146 = 92	183 = B7	220 = DC	
36 = 24	73 = 49	110 = 6E	147 = 93	184 = B8	221 = DD	

Glossary

Alternative Text Tag (ALT tag) A brief explanation of an image that appears when users roll over it.

Background Image An image that forms the backdrop of a Web page; it generally tiles repetitively to fill the monitor screen.

Banner Ad A small advertisement placed on a Web site.

Bitmap Image An image composed of pixels.

Branding (Online Branding) The strategic portrayal of a company through the design aspects and overall style of its Web site.

Browser (Web Browser) A program enabling users to surf the Web.

Cascading Style Sheet (CSS) Coded text that employs a cross-platform language to suggest stylistic and presentational features to be applied through an entire Web site.

Crop Omitted part(s) of an image.

Duotone Image (Duotone Color Image) An image derived from two colors.

Element (Design Element) An object or design feature on a Web site.

Flash (Macromedia Flash) Software that allows users to produce animated and interactive Web elements.

Font A complete set of type of one size and face.

Gamma The brightness level on a monitor.

Graphics Interchange Format (GIF) A method of saving Web images that compresses memory using a color palette; effective for displaying titles and illustrations.

Graphic Authoring Software An image editing and manipulation program that allows users to create a page layout.

Hexadecimal Value (Hex Value) A mathematical representation of a color; related to RGB value.

Home Page The starting point from which users begin to navigate a Web site.

Hypertext Markup Language (HTML) A language used to create Web pages.

HTML Authoring Software Software enabling the creation of HTML documents.

Interactivity/Animation Program A program that allows users to create interactive or animated elements that can be used on a Web site.

Interest Interactivity Interactive features that emphasize desired aspects of a page within the page's design or content.

JavaScript A Web-based language used to create interactive elements.

Joint Photographic Experts Group (JPEG) A method of saving Web images that compresses memory using algorithms; ideal for photographic images.

Link An element connecting one Web page to another.

Logo A combination of a company's name, symbol, and, sometimes, a short tag line; identifies the style or attitude of the company.

Lorem Ipsum Scrambled Latin text used by designers to demonstrate the approximate number of words needed to fill an area of layout.

Masking Hiding or covering part of an image, either sharply or gradually.

Opacity The degree to which an image obscures what is beneath it (opaque image = 100 percent opacity; transparent image = 0 percent opacity).

Panoramic Image An image with a width that greatly exceeds its height and that often pans across a landscape or other setting; often composed of many connected images.

Pixel A dot of light on a computer monitor. Images comprise millions of pixels, each with its own color value (individual pixels are unseen where an image is viewed from afar).

Platform (Operating Platform) A computer operating system (for example, Windows, Mac OS, or Linux).

Pop-Up Page A page on a Web site used to present a small piece of information that does not require an entire page; such a page is generally a scaled-down version of the site's home page.

Privacy Policy A passage indicating an individual or company policy with respect to the confidentiality of information received; common to Web sites that collect data.

Refresh The act of reloading a Web page within a browser.

Resolution Sharpness and clarity of an image based on the number of pixels used.

Sans-Serif (Sans-Serif Font) A type character that does not have an end stroke or foot.

Screen Capture Image of a page taken directly from a computer monitor.

Serif (Serif Font) A type character that does have an end stroke or foot.

Site Map A diagram or flowchart illustrating the navigation structure of a Web site.

Slice Map An illustration showing the breakdown of images on an HTML page.

Subpage A page presenting subsidiary content on a Web site.

System Fonts The few fonts found in all computer systems; often specified in HTML pages to be used on Web sites.

Thumbnail A small version of an image that loads quickly, usually used to provide a quick look at a figure.

Tiling (Tiling Element) An element that repeats until it fills the monitor screen (for example, a tiling background).

Typeface See Font.

Vector Image A line-drawn image rendered using mathematical logarithms.

Index

About the Authors

Avi Itzkovitch has been involved with the world of Web and multimedia design for the past six years, working as a graphic designer, art director, and photographer for various international design firms. Avi is also the founder and president of Multimedia Spatula, a full-service graphic design/multimedia company, and continues to work as a freelance designer. To get more information about Web sites in this book, visit www.multimediaspatula.com

Adam Till has been a writer for the past five years, working with both creative and technical content. He has been employed as a freelance copy/content writer for a number of Web design companies and has also worked as a content manager. A lawyer by profession, Adam possesses an MBA with a finance concentration.